IMAGES
of America

WARREN COUNTY

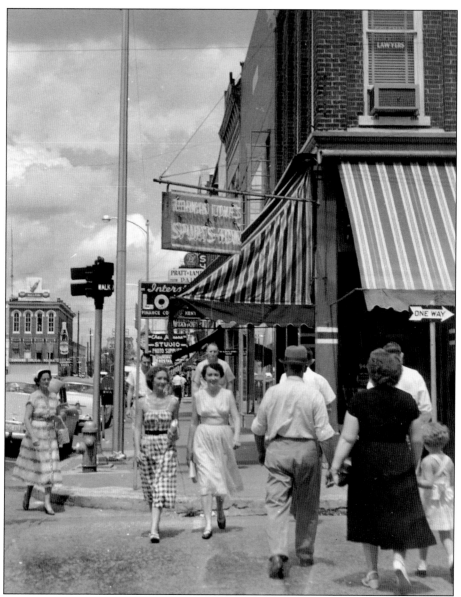

Out for a Stroll. Bowling Green has been the shopping hub for most of South Central Kentucky for centuries now. These folk are out for a day of shopping in the late spring of 1948. The corner store was Herman Lowe's Sports Store on State Street, just one block off busy Fountain Square. In earlier years, this location had been occupied by the old Lon Dodd Grocery. Notice the amount of neon signage used on busy State Street. Of particular interest is the large Coca-Cola sign atop the Ogden Building at the corner of Main and State Streets and the large soda bottle on the side of the same building advertising for a competitor. (Photograph by Herman Lowe.)

On the Cover: Extended campouts on the river were frequent spring and summer events in Warren County. This patriotic group may be celebrating Independence Day at their camp, as the cook has his hand over his heart and several of the boys are waving flags. George Andrews, the cook, has his own cookstove, as seen on the right margin of the photograph, along with some cast-iron skillets to fry the fish these men and boys might catch.

IMAGES
of America

WARREN COUNTY

Jonathan Jeffrey
and the Kentucky Library

ARCADIA
PUBLISHING

Published by Arcadia Publishing
Charleston, South Carolina

Printed in the United States of America

Library of Congress Catalog Card Number: 2006927169

For all general information contact Arcadia Publishing at:
Telephone 843-853-2070
Fax 843-853-0044
E-mail sales@arcadiapublishing.com
For customer service and orders:
Toll-Free 1-888-313-2665

Visit us on the Internet at www.arcadiapublishing.com

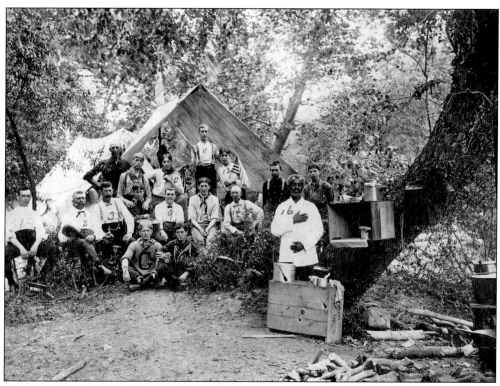

CAMPING OUT. Each of these males in this camping scene are identified with a number: 1. Charlie Bowers, 2. Jack Flairty, 3. John Moltenberry, 4. John Cartwright, 5. Herbert Hendricks, 6. Arthur Hummel, 7. Nibs Allison, 8. Les Dodd, 9. Joe Borrone, 10. Ernest Potter, 11. Porter Dodd, 12. Charles Hummel, 13. Ed Moltenberry, 14. Johnnie Gilbert, 15. Dick Potter, 16. George Andrews, 17. Neal Porter.

CONTENTS

ACKNOWLEDGMENTS

No project like this happens without assistance. I would like to thank my Kentucky Library colleagues Connie Mills, Nancy Disher Baird, and Victor Fife for their patience while this project was being completed. Many of these photographs came from the Kentucky Library's collection, but images from the county are hard to locate. I appreciate the many individuals who helped me find photographs, particularly Pat Motley, Sue Lynn McDaniel, Laurita Sledge, William Sledge, and Frankie Stone. Those photographs that are not from the Kentucky Library have been noted with a credit line following the caption. Lastly I must thank all of the generous patrons who have donated photographs to the Kentucky Library over the last 67 years; without their generosity, this book never would have been possible.

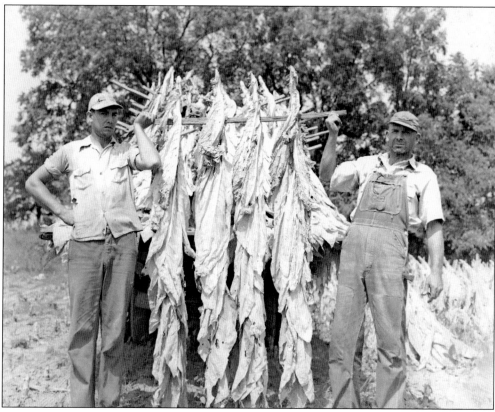

TOTING BURLEY. Tobacco culture is an important part of Warren County's heritage. Farmers and merchants built their lives around the luxurious weed. These men have just finished placing some cut tobacco on sticks to be hung from the rafters of their barn and air cured. Many local farmers have discontinued tobacco cultivation due to buyouts from the federal government. Financial incentives have also been made available for farmers to diversify their crops. The buyouts have caused a rapid evolution in local agriculture.

INTRODUCTION

Kentuckians are very geocentric people. If asked where they are from, they will say, "I'm from Warren County" or "I'm from Barren County." Many times, even if they live in a small town or city of some consequence, they will proudly prefer the name of their county over their municipality. Within a county, they might say, "Oh, I'm from the north end of the county." This interesting custom steered the organization of this book. I chose to have some photographs from the county seat and the area's largest town, Bowling Green, but the majority of the photographs are from the different geographic sections of Warren County. I was very much dependent on people sharing their photographs to complete the project, and I thank those who supplied them.

Warren County was formed in 1797 from adjacent Logan County. After several years of wrangling amongst several tiny communities, Bowling Green was chosen as the county seat and was eventually incorporated in 1812. Other towns were founded in the county, but few grew to any great consequence. Today there are four other incorporated communities in Warren County: Plum Springs, Woodburn, Smiths Grove, and Oakland. The county has an area of 546 square miles, which includes a variety of terrains from rolling hills in the northwest to flat, fertile fields in the southwest and northeast. The land is pierced by numerous sinkholes, as Warren County sits on several significant cave systems. Waterways are plentiful, with three significant rivers: the Barren, Green, and Gasper. Some might even add to this list one of the shortest rivers in the United States, Lost River. There are also several significant creeks, most notably Drakes, Trammel, and Bays Fork.

This book was not intended to be a picture book of famous individuals. There are a few, such as William Natcher and Duncan Hines, but most of the photographs are about everyday people doing everyday things. In these pages are people tending their fields and livestock, fishing, working in the quarries, attending church, eating watermelon, swimming, cooking, playing musical instruments, and simply lolling. This book celebrates the average person.

In compiling the book and looking at numerous photographs, I've drawn several conclusions. They say that data accumulation leads to pattern recognition. In other words, the more data one looks at, the more one is able to recognize patterns and perhaps why they occurred. The photographs I've observed from Warren County show how much people love the land. Farmers are shown standing in their fields admiring their hard work and the blessings of God; they steadfastly plow, till, and nurture the land. They recognize their sustenance comes from the soil. There is nothing quite as a striking as a farmer examining his crops and livestock. An artist might as well be scrutinizing his own masterpiece.

Another observation I made is how much rural people love their animals. In days before mechanization, work animals such as oxen, mules, and horses were essential. They were fed carefully, groomed, and shod; they had shelter. They were also named. Naming something indicates affection. When people showed me pictures from their life, they could name the farm animals. That is touching.

I also observed how much Warren Countians love the water. I found them fishing, swimming, riding on steamboats, paddling skiffs, and picnicking or camping by the waterside. I saw men on log rafts and individuals using the rivers to take their materials to market. I saw ancient mills constructed on waterways. With miles of rivers and streams in the county, it's little wonder that we've negotiated a friendly relationship with the water.

Finally Warren County people like to get together. They congregate for church, school, ice-cream socials, parties, after-church dinners, shopping, and just to talk. They like to stand around the potbellied stove and talk shop. They like to gather in the country store and discuss their crops. They enjoy sitting on the stoop while doing a little courting. They meet in Fountain Square for

all types of events. The church building and the schoolhouse—gathering places—are sacred and indicate the values held by these hardy people.

In conclusion, I discovered anew that Warren County is blessed. We have a lovely terrain that doesn't lean to any extreme. The area possesses fertile land and picturesque waterways. Certain natural resources have been found here in abundance: wood, building stone, and oil. Local industry and commerce thrive. Warren County's most important resource, however, is its people, a people who are innovative, generous, fun loving, and humble, and who enjoy finding solutions to problems together. I am proud to say, "I'm from Warren County, Kentucky."

I must finally remind our citizenry how fortunate our city is to have a place such as the Kentucky Building at Western Kentucky University, which houses the Kentucky Library and Museum. At this facility, professionals have faithfully cataloged and preserved photographs for the last 65 years. Photographs are selected for historic or documentary interest, visual or artistic merit, or interesting clothing or backgrounds. The library owns over 15,000 photographs ranging from daguerreotypes to cyanotypes to tintypes. Prints and negatives are cataloged and stored in acid-free folders and containers. The photographs create one of the most interesting and used collections in the library. I encourage readers to share images with future generations by contributing photographs to the Kentucky Library.

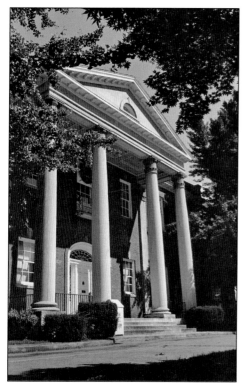

TREASURE CHEST. The Kentucky Building on Western Kentucky University's lovely campus houses the Kentucky Library and Museum. Located here are books, manuscripts, and artifacts related to the cultural heritage of the commonwealth. Collecting Kentuckiana at Western Kentucky University began with a few concerned history professors who felt the need to preserve the commonwealth's unique history. Western Kentucky University's president, Henry Hardin Cherry, championed the idea in the late 1920s, and fund-raising began. Construction of the building, designed by Louisville architect Brinton B. Davis, began in 1929, but the Great Depression halted construction. With money from the Public Works Administration and with the assistance of local architect James M. Ingram, the building was completed in 1939. Each column on the front portico is turned from a single shaft of Bowling Green limestone—one of the many unique things about this attractive structure. A substantial addition was added in 1979. (Photograph by Robert Stuart.)

One

BOWLING GREEN

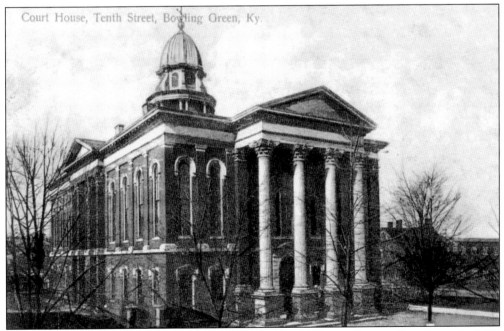

THE SEAT OF JUSTICE. D. J. Williams designed the third Warren County Courthouse in 1867, and construction was completed in 1869. The Italianate structure boasts a classical pediment portico supported by magnificent fluted columns topped with massive Corinthian capitals, all carved from Bowling Green limestone. The architect masterfully crowned his creation with a lovely neo-baroque cupola, which has been rebuilt twice. The building's interior was completely remodeled in the mid-1950s, but little change has been made to the exterior.

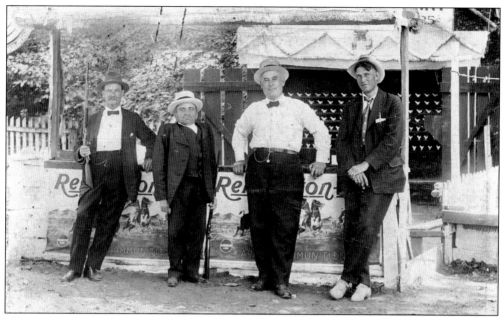

CRACK SHOTS. The two men on the right are ready to test their skill at a shooting gallery sponsored by the Remington Company at the Warren County Fair. The earliest county fairs in Warren County took place in the 1840s and continued off and on until the late-1920s. The fair went defunct in the 1930s, but it was eventually revived as the Southern Kentucky Fair, or the SOKY Fair, in 1952.

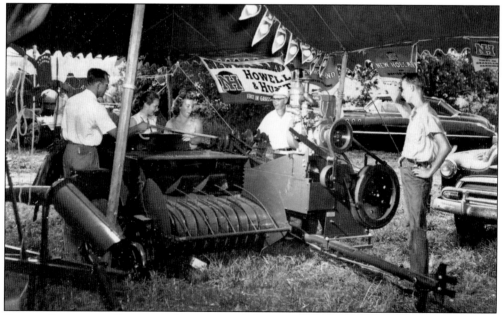

SELLING EQUIPMENT. One reason farmers attended county fairs was to check out new and improved ways of doing things. Fairs were entertaining and educational; for some people fairs were even profitable. Here Homer Howell (in center with white shirt and hat) is trying to interest folks in a new hay baler being offered by his company, Howell and Hunt Implement Company of Bowling Green. (Courtesy of Alicia [Howell] White.)

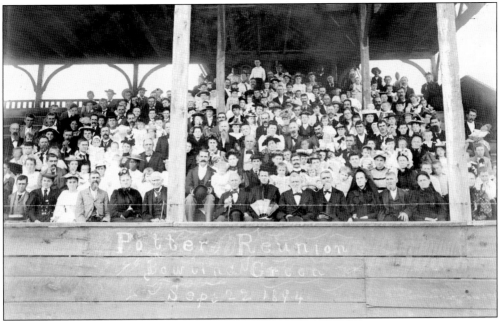

FAMILY REUNIONS. Getting the whole clan together at least annually is an important commitment for many families. This photograph documents the Potter family reunion held on September 22, 1894, in Bowling Green; the family has assembled at the old fairgrounds grandstand. Some families take the annual or biannual opportunity to clean up family cemeteries, and few of these events go by without a huge outdoor meal to celebrate the culinary creativity of family members.

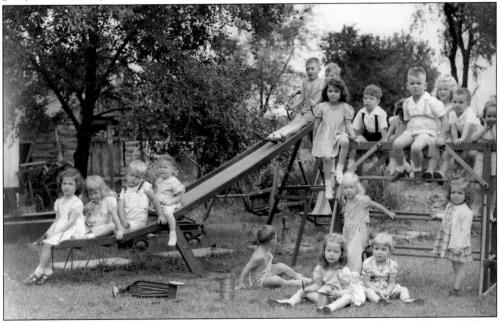

PLAYTIME. Every child's desire in the spring is to be outside playing with friends. These children actually got to attend "play school," or kindergarten. This photograph was taken *c.* 1945, a time when there was no preschool program in the local public schools. This "play school" was operated by Cornelia H. McGeehee at 513 East Seventeenth Street.

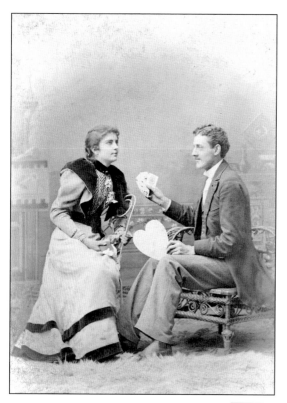

PLAYING HEARTS. Kate Meyler was obviously quite a coquette in late-19th century Bowling Green. Here Preston Potter is attempting to present Kate his heart. With cards in his hands, perhaps he realizes that this is a gamble. Kate seems unimpressed.

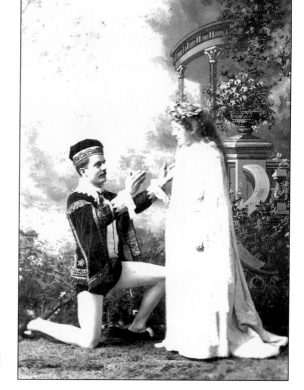

PLEASE DARLING. Costumed for participation in a drama, Kate Meyler and Dr. William Desobry ham it up for the camera. The play is unnamed, but on the back of the photograph, Meyler is identified as Princess Rosethorne and Desobry as Prince Wolfgang.

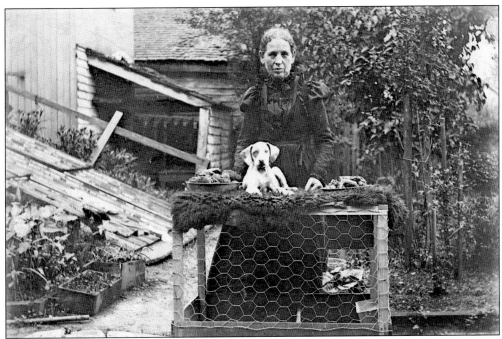

HOW DOG WILL TRAVEL. Pictured here is Mary Armitage of Bowling Green with her dog, Gainsy, in 1892. Armitage is preparing to visit relatives in Fresno, California, and Gainsy is going along. The cage has been built specifically for the purpose. The inscription on the back notes that Armitage "sent fried chicken and an old shoe to chew on in the box."

PAMPERED POOCH. This confident poodle, Pinky Prim, belonged to Louise Farnsworth and family. Farnsworth, who lived at the corner of Chestnut and Thirteenth Streets, loved animals and children. She taught elementary school classes for over 40 years. After class, she went home to her pets: dogs, cats, and birds. One particularly well-known Farnsworth pet was a parrot that used to call to people passing on the street.

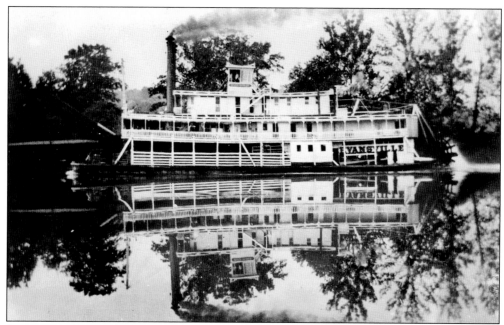

STRIKING A POSE. The *Evansville* was built in Cincinnati in 1880 and was sometimes referred to as one of the "eight wonders of the world." The other eighth wonder was the *Evansville's* sister boat, the *Bowling Green*. The *Evansville* was 120 feet long and 30 feet wide. These two boats plied the Barren and Green Rivers delivering people and freight. The *Evansville* burned at the Bowling Green wharf in 1931. (Courtesy of Courtney Ellis Collection, Western Kentucky University [WKU].)

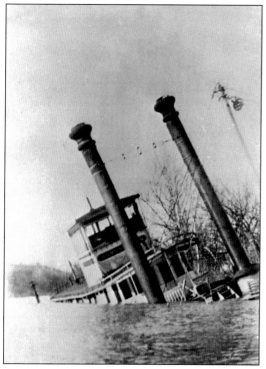

A SINKING FEELING. This rare photograph of the sunken steamboat *Bowling Green* was taken by Rena W. Crabtree on March 31, 1920. During a storm that evening, the boat hit a rock on the bank that caused a hole the size of a barrel. The 132-foot-long *Bowling Green* was built in 1904 by the Howards of Jeffersonville, Indiana. At the time, she was the third boat to bear that name.

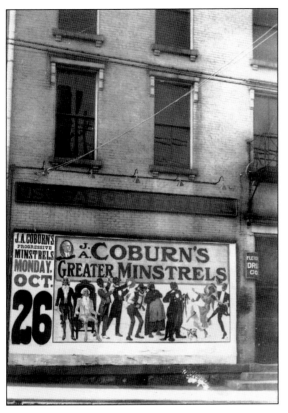

COMING ATTRACTIONS. This is a rare photograph of a large poster advertising an appearance of J. A. Coburn's minstrel show in Bowling Green. This particular troupe made frequent stops in Bowling Green, and several local thespians, such as Billy Blackwell, actually joined this traveling company. The poster has been pasted on the Main Street side of the Quigley-Younglove Building. Notice directly to the right of the poster the small sign for the Fletcher Drug Company, a longtime occupant of that structure.

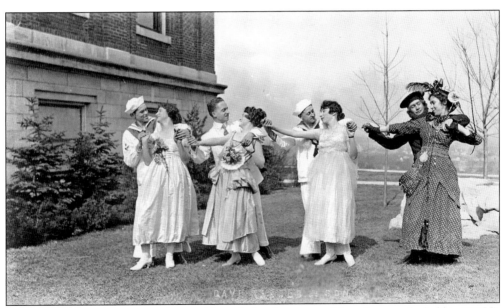

STRIKING A POSE. This unusual ensemble is obviously costumed for a drama to be held in WKU's Van Meter Auditorium. The costumes beg for explanation. After Van Meter's completion in 1911, WKU moved from its downtown location to College Heights. Van Meter was the site of the school's daily chapel services and the location for numerous cultural, religious, and civic events.

15

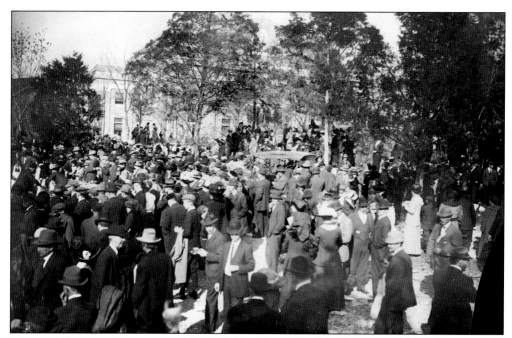

WARREN COUNTY CONVENTION. In 1913, Dr. Henry Hardin Cherry, president of WKU, held a series of farmers' chautauquas in Warren County that culminated in a mass meeting held at Western's hilltop campus on November 12, 1913. To promote a large attendance, city leaders asked that all businesses close from 11:30 a.m. to 1:30 p.m. and that public schools dismiss classes at 10:30 a.m. (Courtesy of University Archives, WKU.)

BURGOO APLENTY. Burgoo is a stew consisting of vegetables and various kinds of meat, particularly wild game. The local paper reported that over 500 gallons of burgoo, "seasoned to a queen's taste," was prepared for the crowd at the mass meeting on Western's hill. No doubt many a mouth salivated on that cold November day as the savory smell of burgoo wafted over Western's hilltop. Besides burgoo, local cooks provided barbecue lunches for approximately 5,000 people. (Courtesy of University Archives, WKU.)

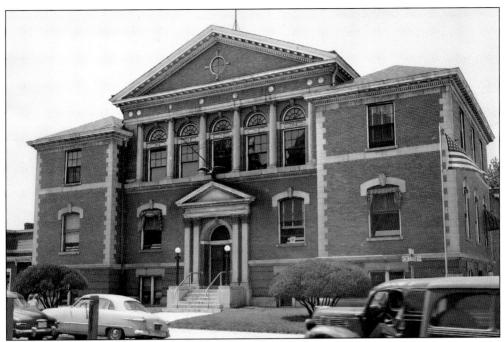

THE HOME OF CITY FATHERS. Bowling Green City Hall was built in 1907. Mayor George T. Wilson and the city council hired Louisville architect Brinton B. Davis to design this Classical Revival structure. This photograph was taken on May 10, 1951.

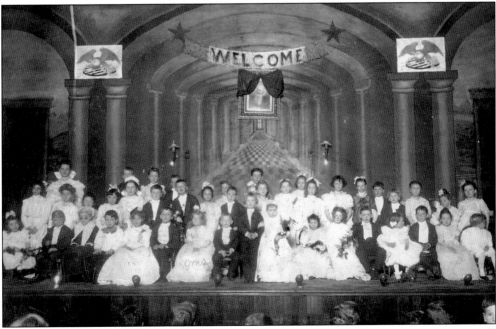

TOT NUPTIALS. This photograph of a Tom Thumb wedding was taken inside Van Meter Hall on the campus of WKU in 1906, when it was located on Center Street. The bride and groom featured in the center are Marjorie Leichhardt and Jesse Sweitzer. A portrait of Jacob Van Meter is centered above the stage and is draped.

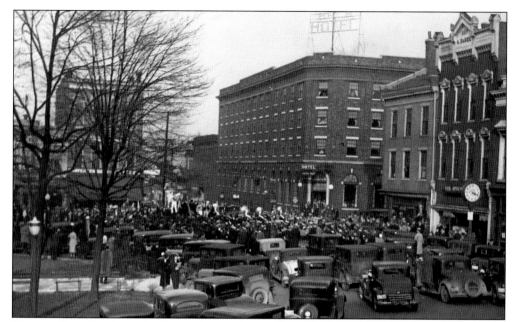

TRAFFIC JAM. Parades and public gatherings have often attracted people to the Fountain Square area. Here what appears to be a parade is actually some type of Western pep rally being held in front of the Helm Hotel on State Street. Several Western cheerleaders sporting W letter sweaters and wielding megaphones are trying to bolster the old Western spirit amongst the crowd.

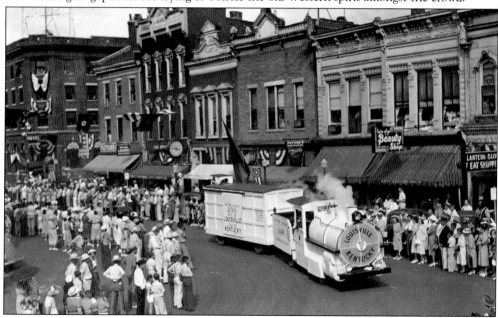

A PARADE! Bowling Green loves a parade, and several are still held annually. Parades typically include the popular Fountain Square Park on their routes. One of the largest parades held in Bowling Green's history (pictured) was for the state convention for the American Legion, held here in late-1930s. Flags and bunting adorn buildings for the occasion. Besides the viewers at street level, many watch the parade from second-floor windows. Some are even out on the roof catching a glimpse of the passing attractions.

KINGS OF THE COURT. The Bowling Green YMCA was started around 1908, and a building was eventually erected for the organization at the corner of State and Eleventh Streets. It hosted games and tournaments for various sports teams, including basketball. Here the team sponsored by Dave Rabold, a merchant on Fountain Square, displays the winning trophy for the 1913 basketball tournament. From left to right are (first row) J. C. Lawson (captain with trophy); (second row) Ralph Ray, E. Riley (referee in turtleneck), Undy Hines; (third row) H. Bradley, L. B. Jones, Homer Combest, and Vic Strahm.

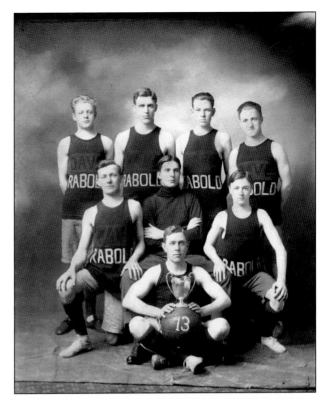

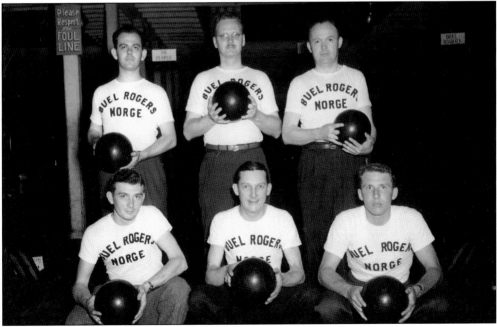

PIN HEADS. These men are bowling in the late 1930s for the Buel Rogers team. Rogers ran an appliance store on East Tenth Street, across from the courthouse, that sold gas and electric appliances manufactured by Norge, including radios, vacuums, washers, ranges, refrigerators, and heaters.

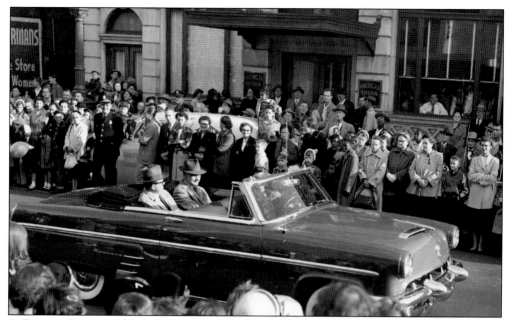

A FLASHY DEBUT. Although the date and subject of this photograph are not identified, the gentleman on the right in the automobile is Mayor Elvis Campbell. What is the crowd out for? A good guess, judging from the coats and from the children present, is one of Bowling Green's Christmas parades. These parade watchers are standing in front of American National Bank on State Street. Since Bowling Green's mayors are sworn in during the month of January, the parade could possibly be for that event.

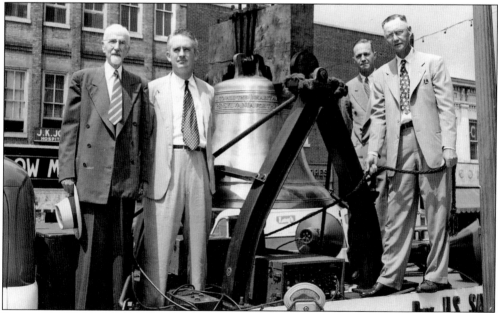

RING THE BELL OF FREEDOM. A replica of the Liberty Bell traveled throughout the United States in 1950. Getting ready to ring the bell here on Fountain Square on June 15, 1950, are, from left to right, John B. Rodes, Marshall Funk, Fred Spires, and Elvis Campbell. The float's sign proclaimed the purpose of the bell's sojourn was to encourage people to purchase U.S. savings bonds.

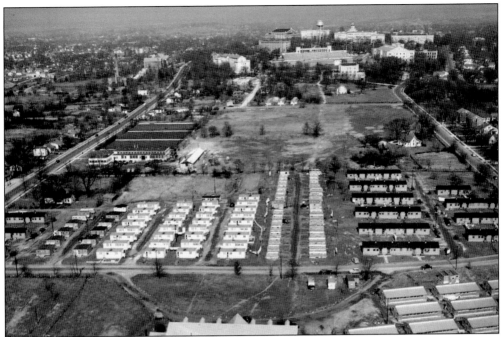

VETERANS' VILLAGE. Student accommodations could not handle all the men, particularly married males, who wanted to attend WKU after World War II. Pres. Paul Garrett procured a total of 65 buildings from military surplus, including "knock down houses," double-wide trailers, army barracks, and large, prefabricated structures that he divided into apartments. The ragtag group of buildings was situated on the western end of campus and became known as Vet Village. The village did not completely disappear until 1976. (Courtesy of University Archives, WKU.)

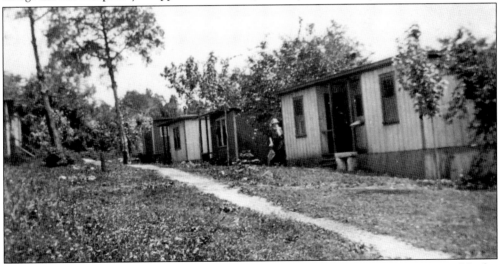

TRYING TO MAKE DO. During another time of housing shortages at WKU, Dr. Henry Hardin Cherry had these temporary abodes built in an area near the Kentucky Building on campus. The housing was chiefly used by married students. The area was affectionately referred to as Cherryton in honor of Dr. Cherry's efforts to ease the tight housing situation in Bowling Green that was caused in large part by the influx of laborers working on rigs during the area's oil boom of the 1920s.

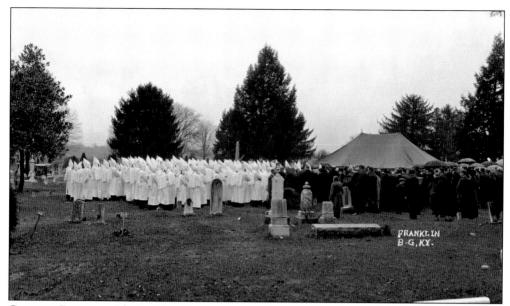

GHOSTLY FUNERAL. The Ku Klux Klan was particularly strong in Bowling Green during the 1920s. By putting this photograph under intense magnification, several of the tombstones are readable. This scene took place in Fairview Cemetery and was documented by one of Bowling Green's best photographers, Eugene Franklin. Despite the cool, dreary weather on this South Central Kentucky day, numerous people—including a large contingent of white caps—have turned out to honor the deceased, who is not named. The floral cross being carried by the second Klansman from the right (below) was one of the chief symbols of the KKK. An account book from a local florist noted that in 1925 the "Ladies KKK" purchased a floral cross for $10. Klan meetings were not necessarily clandestine; a showing of *Birth of A Nation* was "shown under the auspices of the Warren County KKK" at Lost River Cave in July 1924. Another upsurge in local Klan activity took place in the last decades of the 20th century. (Photographs by Eugene Franklin.)

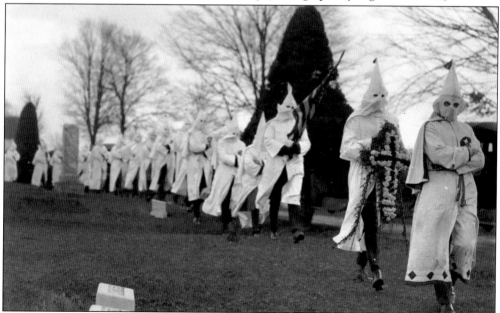

THE POSTMAN RINGS TWICE.
This is Bowling Green postman Charles Owens loaded down with parcels to take on his rounds, probably around 1915. One has to wonder what some of these odd shaped packages contained, particularly the item with two legs that Mr. Owens has hanging from his neck.

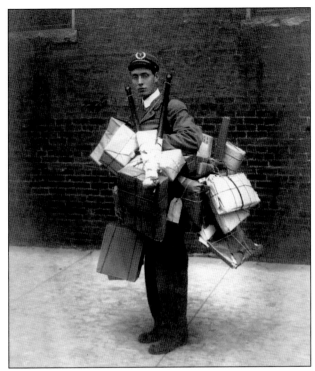

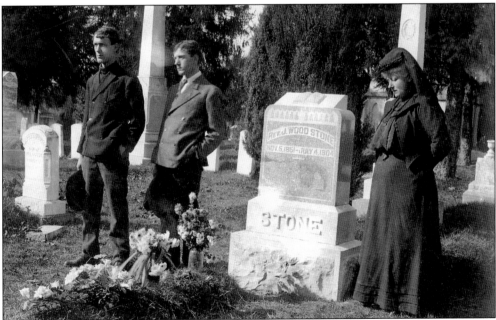

STONE COLD. Here members of the J. Wood Stone (1851–1904) family are gathered around his tombstone at Fairview Cemetery. Pastor Stone died in Bowling Green while serving the local Cumberland Presbyterian Church. His wife sent this photograph to family members in Texas, showing that the church had purchased a marker resembling a pulpit for his grave. Pictured are his wife, Josephine Belle (Goodrum) Stone (1855-1941), and his two sons (left to right) Silas (1888–1922) and Paul (1886–1952). (Courtesy of Sue Lynn McDaniel.)

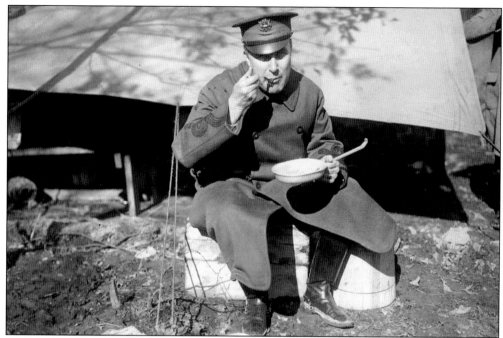

AT SAND CAVE. At Sand Cave. Brig. Gen. and Kentucky's Lieutenant Governor Henry H. Denhardt (1867-1937), of Bowling Green, is shown here consuming a light meal while aiding in the rescue efforts to extract Floyd Collins (1887-1925) from the Sand Cave. Collins had been exploring Sand Cave in order to find a more convenient entrance to his family's cave, which was open for touring. Collins died before they were able to remove him from the cave. The event brought national attention to the Mammoth Cave region.

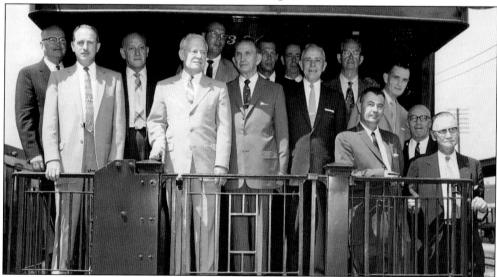

I'VE BEEN WORKING ON THE RAILROAD. This large group of Bowling Green civic and railroad leaders had their photograph taken on the back of a train to celebrate Railroad Appreciation Day on June 14, 1958, at Beech Bend Park. The Louisville and Nashville Railroad continued to employ many people from Warren County in the 1950s, and local industry and agriculture were dependent on the railroad to help get local products to market.

Oops! The Louisville and Nashville (L&N) Railroad has been an important part of Bowling Green's history since the line was completed in 1859. It allowed goods to be sent to different markets, provided reliable passenger service for local residents, and paid a hefty payroll to locals who worked for the system. There were occasionally problems, such as labor disputes, deaths caused by accidents, diseases brought from outside, and derailments. This particular derailment took place in April 1978. (Photograph by Jim Burton.)

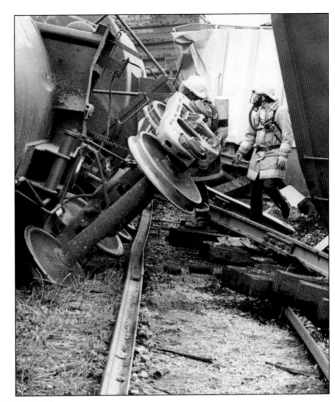

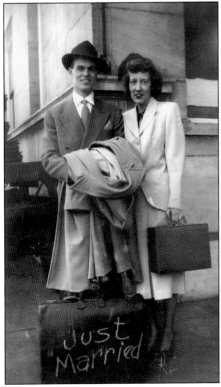

JUST MARRIED. Eva Mae Stone married Vaughn Monroe Stevens on December 20, 1947. They are standing at a corner of the depot about to depart for Cincinnati for their honeymoon. Someone helped document the event for future generations by writing "Just Married" on the couple's bag. (Courtesy of Sue Lynn McDaniel.)

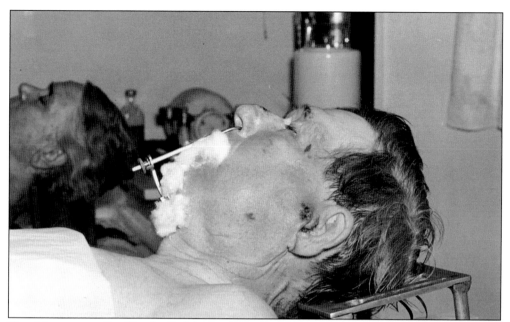

THE MURDERED. Dr. Charles B. Martin (1864–1948) and his wife, Martha (1876–1948), are shown here in their autopsy photographs. The Martins were murdered on June 30, 1948, in the bedroom of their lovely, Greek-Revival home on Cemetery Road. The photograph of the crime scene below shows the ghastly amount of blood lost by Mrs. Martin as she died in the bed; the blood on the wall and floor from Mr. Martin indicated that there was a struggle when the murder took place. The couple was killed by Harry Edward Kilgore, a physics major at WKU. He had fallen in love with Ruth Ann McKinney, who became interested in the Martins' son, Stonewall. The Martins were reputed to be quite wealthy, and greed certainly entered into the picture. Kilgore was convicted for the murders but was released after he served a number of years in prison. (Courtesy of W. H. Natcher Collection, WKU.)

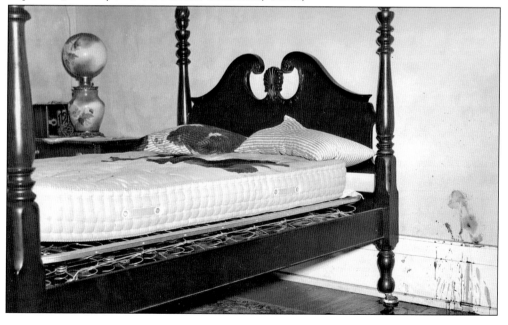

A CONGRESSMAN WITH A
RECORD. William H. Natcher
(1909–1994), a Democrat,
represented the Second District
of Kentucky from 1953 to 1994.
Previously he had served as
county attorney (1938–1950) and
commonwealth attorney (1950–
1953). Congressman Natcher has
the longest record of consecutive
roll-call votes in the House with
18,401 votes cast. He is pictured in
the early 1990s, when he cast his
18,000th vote. (Courtesy of W. H.
Natcher Collection, WKU.)

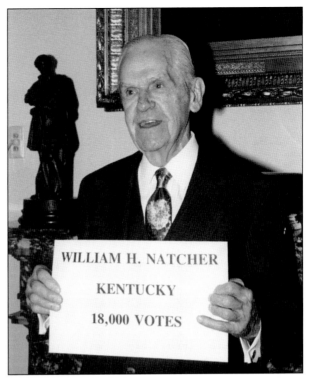

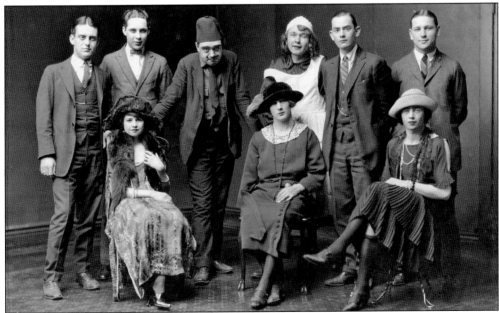

DRESSED TO KILL. Ogden College was an all-male institution located where the Thompson
Science Complex at WKU is today. The college existed from 1877 through 1927. When presenting
plays, the female characters had to be portrayed by male students. This is a photograph of the
cast of *Safety First*. From left to right are (first row) Carter Massey, Harlan Chambers, and L. S.
Fant; (second row) Claude Kinslow, David Sledge, Laurence Duncan, Hollins Lashmit, Murice
Burton, and Edward Schwartz. (Courtesy of University Archives, WKU.)

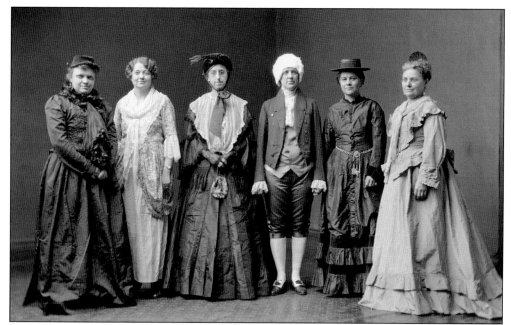

FROM ANOTHER GENERATION. These women are dressed for an event held at the Kentucky Building, which was sponsored by the Business and Professional Women's Association in Bowling Green. The only woman identified is Mackie Bennett, the third woman from the left. Bennett was active in Eastern Star, the State Street Methodist Church, and a number of other organizations.

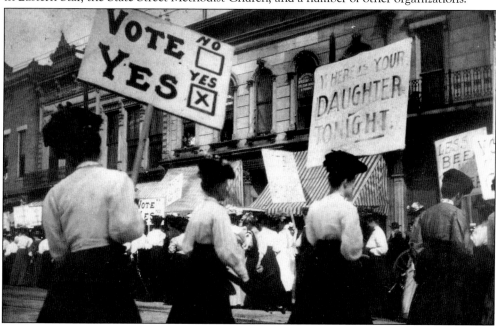

FEMALE PROTEST. What might appear to be a suffrage march on June 6, 1907, is actually a display of support for prohibition in Bowling Green. The city has experienced an inordinate number of local option elections. The march strategically followed a religious revival led by renowned prohibition speaker and local evangelist Mordecai F. Ham. The community did approve prohibition in 1907, but it was reversed in another acrimonious referendum in 1910.

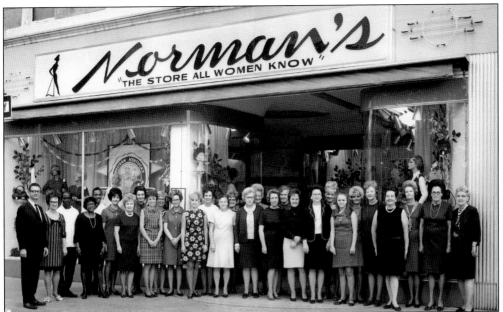

THE STORE ALL WOMEN KNOW. Opened in 1930 by Ely Norman, Norman's was one of Bowling Green's favorite dress shops. Norman employed local architect James M. Ingram to design the arresting art deco storefront shown here. This photograph documents a back-to-school sale at the store in the late 1960s. In its heyday, it was "the store all women know," and, as one local disc jockey added, "all men owe."

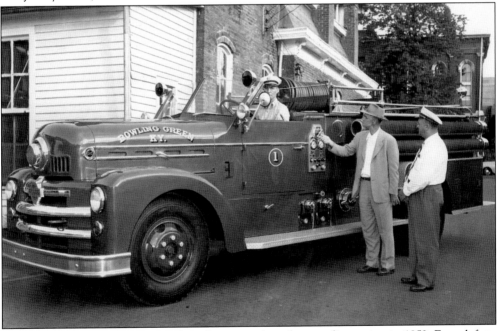

So THIS IS HOW IT WORKS. Bowling Green purchased a new fire engine in 1952. From left to right, Bennie Harrod, Mayor Elvis R. Campbell, and fire department chief Brett Basham are checking out the new machine. At the time, Bowling Green's central fire station was located behind city hall.

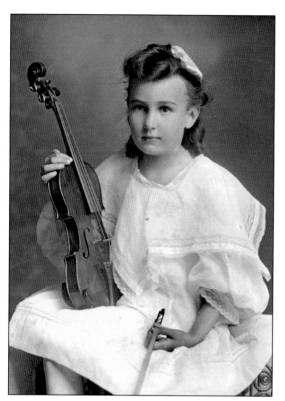

A GIRL WITH A BOW. Cecilia "Cecil" Josephine Obenchain was the daughter of noted author Lida Calvert Hall and the president of Ogden College, William A. Obenchain. She was an accomplished musician, and her name appears on many Bowling Green musical programs from the first half of the 20th century.

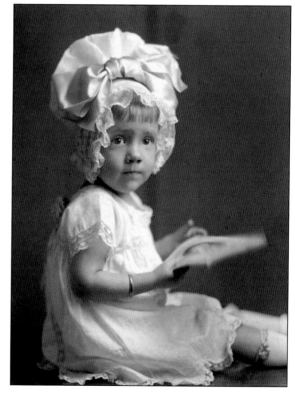

A LITTLE GIRL WITH A BIG HAT. Eva Mae Stone is dolled up for this portrait. She has on her silver bracelet, her white lace-trimmed dress, and a most unusual bonnet. Eva Mae was approximately 16 months old when this photograph was taken. (Courtesy of Sue Lynn McDaniel.)

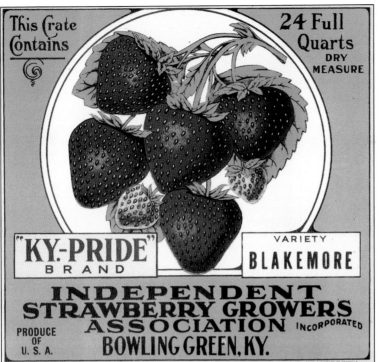

STRAWBERRY FIELDS FOREVER. The Bowling Green Independent Strawberry Growers Association was one of four cooperatives in the county related to this red, juicy fruit. Each had its own board of directors. These associations helped purchase supplies and plants, and more importantly, they helped recruit labor and market the fruit.

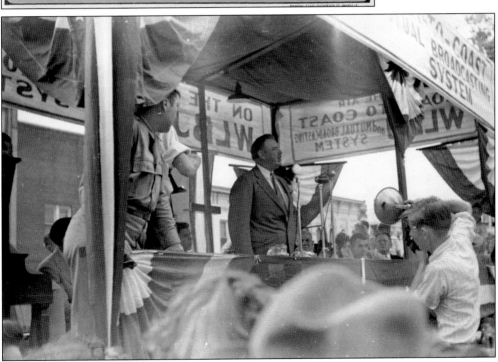

RADIO PERSONALITY. Bowling Green's first radio station, WLBJ, was known as "the Friendly Voice in Southwest Kentucky." The station went on the air June 25, 1940, and signed off in 1991. Owner L. B. Jenkins is seen at the station's dedication. The call letters for the station were actually Jenkins's initials.

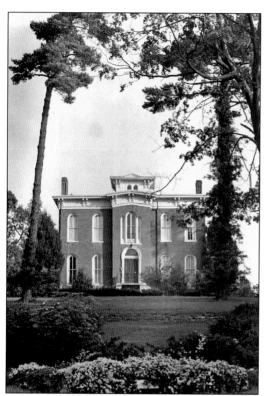

A HOUSE ON A HILL. Riverview at Hobson Grove was designed by D. J. Williams, the same architect responsible for Warren County's 1860s Italianate courthouse. Atwood and Julia Hobson moved into the home after its completion in 1872. Family members lived in the house until the early 1950s. It became a city property in the late 1960s and today is Bowling Green's only house museum.

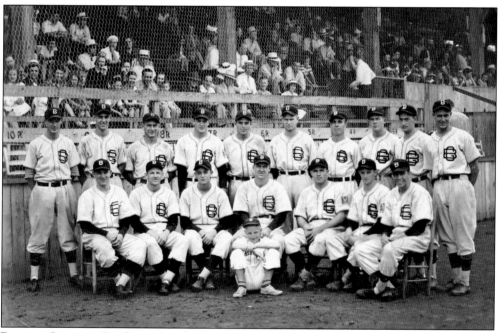

BOYS OF SUMMER. Bowling Green had organized baseball teams as early as 1887. This team is from the 1940 season, and it looks like the home crowd is out to support them. The team played in the Class-D Kitty League; this regional organization lasted from 1903 until 1955. (Courtesy of Rosalyn Stamps.)

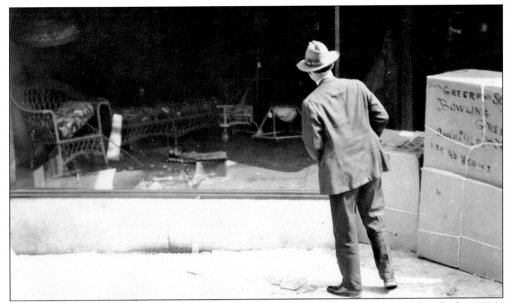

BULL RUN. In 1930, shoppers roaming around Fountain Square were surprised to find a 1,390-pound Hereford bull running about. He had escaped from the L&N stockyards and had come up Tenth Street. He then moseyed over to Park Row, where he jumped through the plate glass window of the Greer Furniture Store. An article from the local newspaper noted: "After wrecking the furniture on display in the window due to an inability to stand up on the highly polished hardwood floor he went into the store, found it not suited to his tastes and left via a large plate glass window on the 10th Street side of the store." (Photograph by Herman Lowe.)

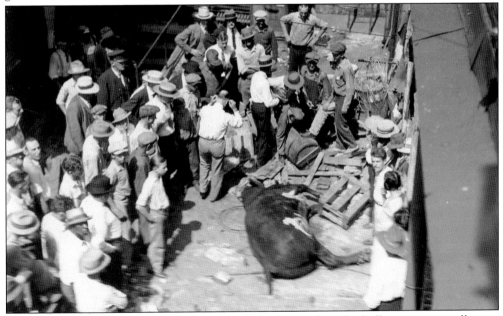

FINISHED. After crashing through Greer's back display window, the bull ran into a small space behind the Presbyterian Church. By this time, a crowd of 500 had gathered to follow the behemoth bovine. Eventually a Mr. Shields shot the bull behind the Daughtry plumbing concern on Tenth Street. The animal did $500 in damages to the Greer store. (Photograph by Herman Lowe.)

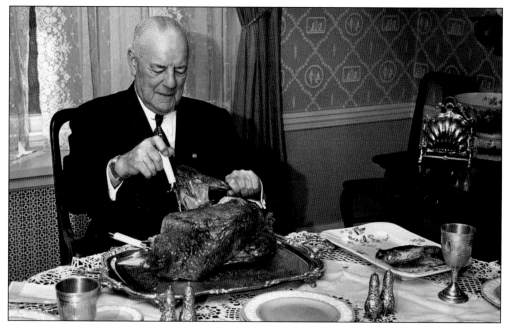

CULINARY ENTREPRENEUR. Duncan Hines (1880–1959) is perhaps the most recognized name that Bowling Green has ever produced. Hines worked for printing companies in Chicago for 33 years before producing his popular *Adventures in Good Eating* guides, which listed restaurants that offered "standout attractions in the culinary department." Here Hines is getting ready to do some carving, which he considered an art, and he always included instructions for carving meat in his cookbooks.

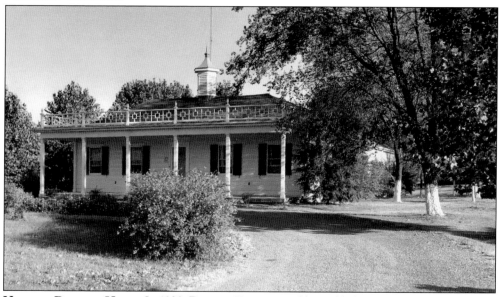

HOME OF DUNCAN HINES. In 1938, Duncan Hines moved his publishing business from Chicago to his hometown of Bowling Green. Two years later, he purchased four acres on the Old Louisville Road (Highway 31 West) to build this attractive house/office. The house's facade was patterned after the back portico of Mount Vernon, George Washington's Virginia home. The house is now a funeral home.

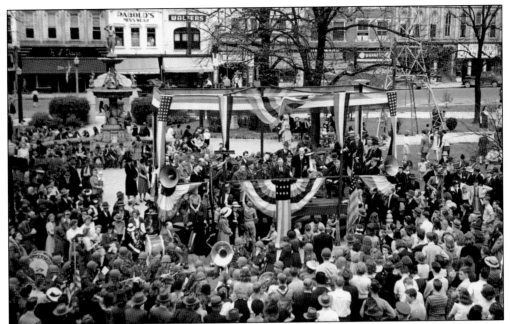

A CROWDED FOUNTAIN SQUARE. This undated photograph documents one of several large war bond rallies held downtown during World War II. Major speakers, including heroes such as Sgt. Alvin York, came to Bowling Green to encourage local citizens to generously support the war effort. What appears to be an antennae tower to the right of the speakers' platform is actually Bowling Green's World War I memorial.

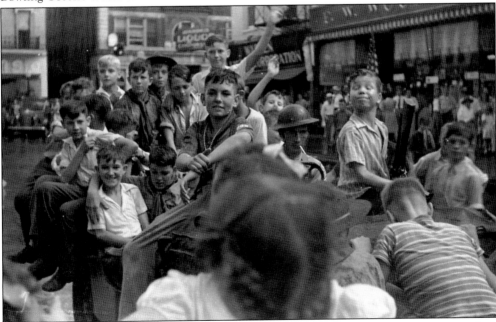

LIVING IT UP. Bond rallies were popular times for the whole community to congregate together. Here a group of boys has piled atop one of the military jeeps that were brought to advertise the event. They are at the corner of State Street and Park Row in front of the F. W. Woolworth store. Notice the boy found directly to the right of the military driver; his expression is priceless.

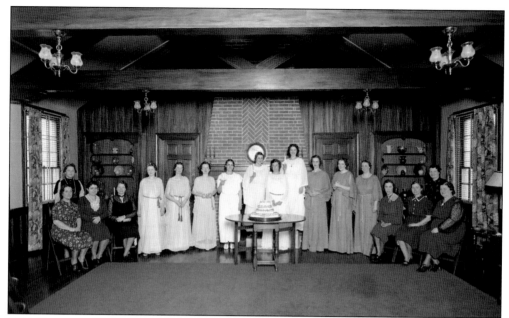

PTA ENCLAVE. These ladies are gathered for a symbolic installation ceremony of the Bowling Green Parent Teacher Association Council, which consisted of representatives from various school PTAs in the city. This meeting appears to be from the late 1930s and took place in the Honey Krust Hostess House located next to the bakery on Adams Street.

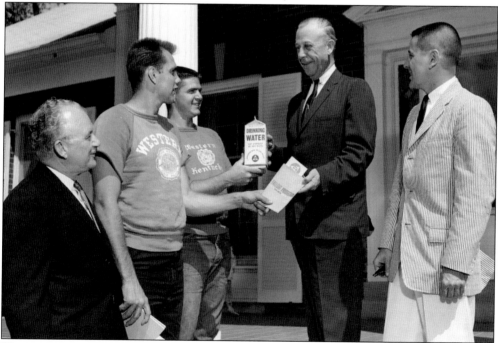

WATER DELIVERY. These WKU students are participating in a campaign to deliver boxed water to be stored in home fall-out shelters. This project was cosponsored by Brown All Star Dairies and the city. The young men are presenting the water to Mayor Robert Graham at his home on Normal Avenue.

Two

NORTHEAST WARREN COUNTY

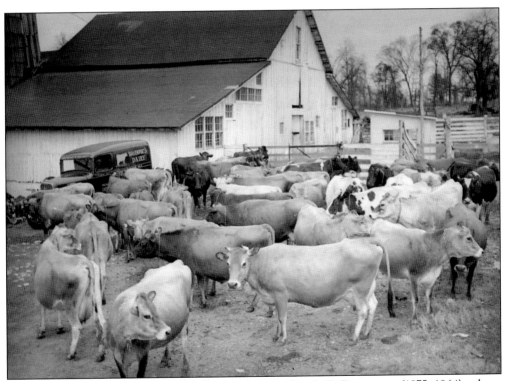

MOVE IT. This handsome herd of milk cows belonged to J. C. Davenport (1875–1964), whose farm was located off Beech Bend Road. Davenport was the first dairyman in the Bowling Green area to qualify in the production of Grade A milk. His operation was universally admired; it was featured in a 1936 article in *Hoard's Dairyman*, a national trade publication. The article's author referred to Davenport's cows as the "comfortable kind that one likes so well to see."

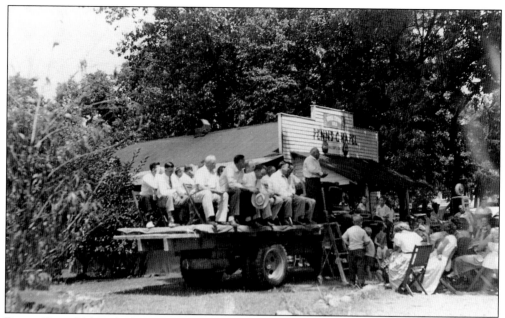

RALLY DAY. Although the purpose for this gathering at Penns Chapel is not noted, it appears to be a political rally. The crowd does not seem dressed for a religious service; several boys are shirtless, and one woman is smoking a cigarette. The location is the old Wilson's Grocery at Penns Chapel. If one looks carefully at the store sign, it is flanked by round Coca-Cola advertisements and topped with a Royal Crown Cola sign. The lone gas pump can be seen at the right margin.

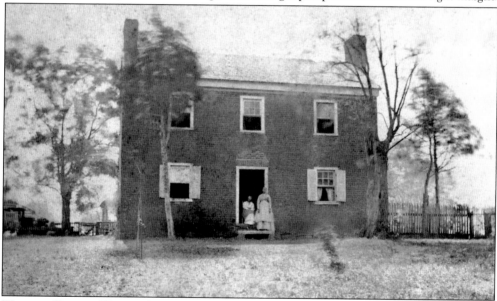

WILLIAM GOSSOM HOME. This home was located on the Old Louisville Road before the highway was moved; today the front of the home faces the Plum Springs Loop. One of the oldest brick structures in the county, the Gossom Home is believed to have been erected prior to 1820 by William (1774–1862) and Elizabeth Gossom (1778–1871). Family legend holds that Jenny Lind, the "Swedish Nightingale," once stayed with the Gossoms. The family is buried in the Gossom-Roberts cemetery south of the property across Highway 31 West.

CANNING QUEEN. Rovertie (Bolen) Wills is participating in an annual ritual that takes place every summer in homes across Warren County. She is canning vegetables—in this case, green beans—from her garden. Canning was more than a necessity for Wills; she liked the look of the vegetables on display, even arranging her canned fruit and vegetables by color.

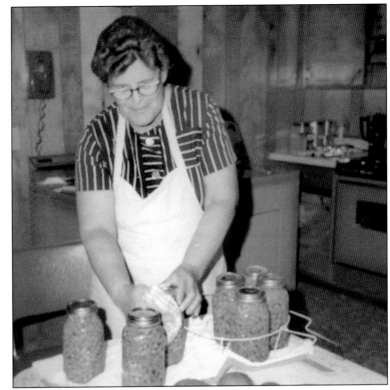

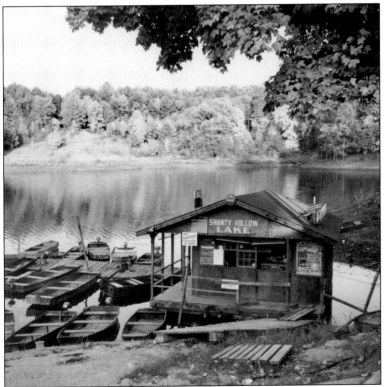

RULES, RULES, RULES. Shanty Hollow Lake is a shallow fishing lake located in northeastern Warren County near Glenmore. The lake's "marina" posted a number of regulations for guests. One sign notes that no shooting is allowed, and no firearms are permitted. Another sign prohibits fishing from the marina's pier. How's someone to have any fun?

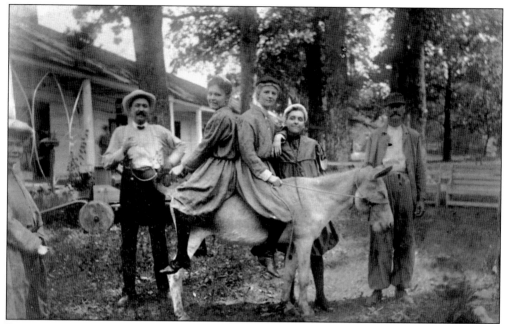

READY TO SPELUNK. Although this photograph was taken in Edmonson County, a portion of the party shown was visiting a Warren County family in the Smiths Grove area. The ladies are dressed in bloomers and have their hair pulled up in preparation to tour Mammoth Cave. Mules often conveyed guests to the cave's entrance and sometimes beyond. Mammoth Cave remains Kentucky's most visited tourist site.

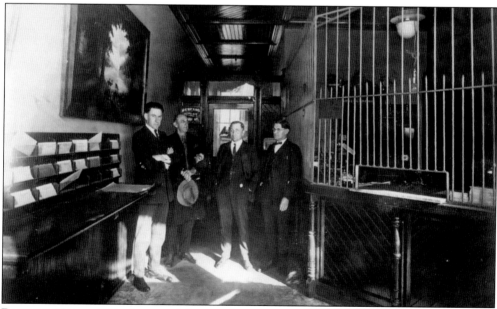

BANKING HOUSE. This photograph features four prominent Smiths Grove residents in the lobby of the Farmers Bank. The teller's wicket features a beaded board wainscoting, a marble counter, and a simple cage. Notice the beautiful beaded wood ceiling and the large, attractive painting that decorates the lobby. The men are, from left to right, M. H. Kirby, D. T. Harris, Gray Y. Turner, and R. E. Beard.

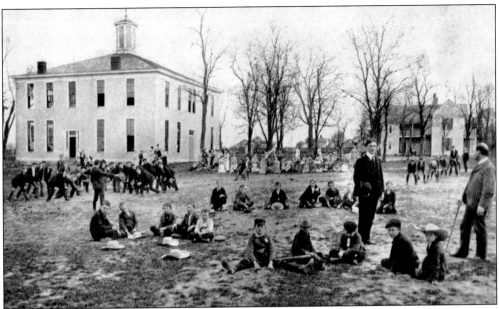

HOUSE OF SCHOLARS. The Vanderbilt Training School in Smiths Grove was part of a series of preparatory schools established by Nashville's Vanderbilt University. A similar school was established in Elkton. The school, located near the present site of North Warren Elementary School, was initially built as Smiths Grove College and later served as Warren Academy, which was operated by the Warren Association of Baptists. This staged photograph shows the children out for recess; notice that the genders are separated.

ANOTHER VIEW. This group is holding a picnic on the grounds of the old Smiths Grove College. The building went through a number of name changes. The school was known as the Vanderbilt Training School, the Warren Baptist Academy, and even later as the Smiths Grove School. In this photograph taken on April 3, 1921, the school looks a little disheveled, with several windowpanes broken out. This rear view of the building also shows the fire escape and the ubiquitous basketball goal on the playground.

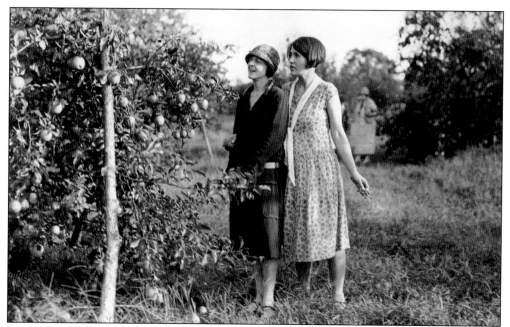

FRUIT WATCHING. These young ladies, dressed in their 1920s finery, are out observing the fruit in an orchard in the northeast section of the county. Warren County is blessed with a growing season adequate for tree fruit, chiefly peaches and apples. Few pear or cherry trees were ever grown commercially here.

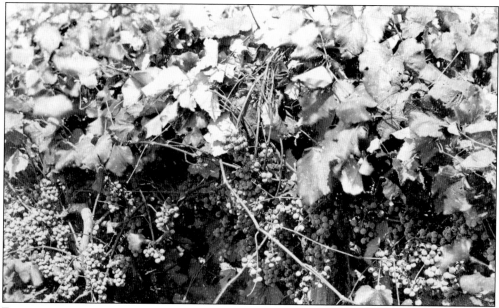

FRUIT OF THE VINE. Warren County has never been an important grape producing area, but vineyards have been planted here. Vineyards were once located on the southeast side of College Hill (now known as Hospital Hill). Upon examining the 1877 Beers map, one can also find several vineyards scattered across the county. Perhaps the best known was the Donaldson Vineyard, located across Ewing's Ford on the Barren River. Grapes were used for making homemade wine and jellies.

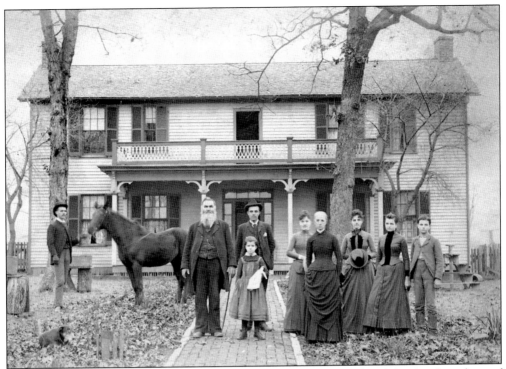

THE LUCAS FAMILY. Nathaniel Henry Lucas (1818–1908) is pictured with his family in front of their home on Highway 68-80. Nathaniel built his new house on the exact spot of his ancestral home, which had been burned by Union soldiers during the Civil War. The people are identified from left to right as Henry Jr., Nathaniel, Lee, Clyde (girl with doll), Virginia (Lucas) Helm, Mary (Maury) Lucas (older lady in front), Clara (Lucas) Helm, Mattie (Lucas) Cowles, and Joe.

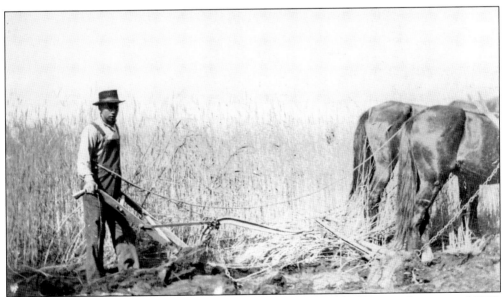

PLOWING. This farmer in his overalls is out plowing a section of the Eastview farm around 1920. He is still using the old-fashioned method with mules and a hand-held plow.

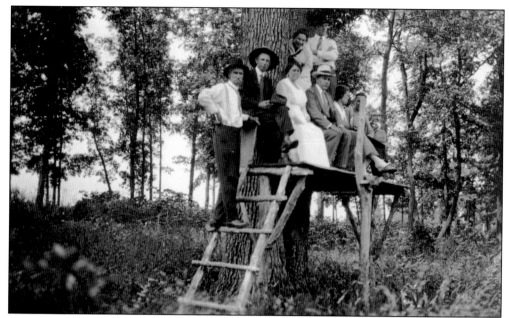

AIRY PERCH. The owners of Eastview, a farm off the Glen Lily Road, liked the view so much from their home they built an overlook where they could spend their spare moments enjoying the surroundings. The family referred to the site as the Outlook.

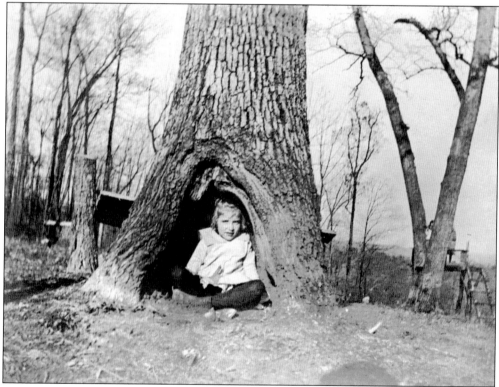

A SPRITE. While adults enjoyed the view from the overlook at Eastview (on the right margin of the photograph), little Elizabeth Rodes has squirreled away in the trunk of a tree in 1916.

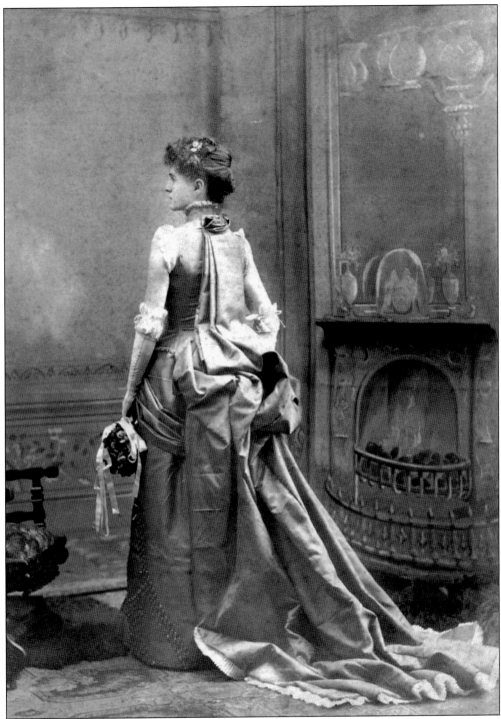

DRESS FOR A QUEEN. This photograph documents the spectacular wedding dress of Mildred Carpenter, who married James Harvey Tucker on June 19, 1888. She was 19 at the time of her marriage. Her gold silk dress was made by Bowling Green's best-known modiste, Carrie Burnam Taylor (1855–1917).

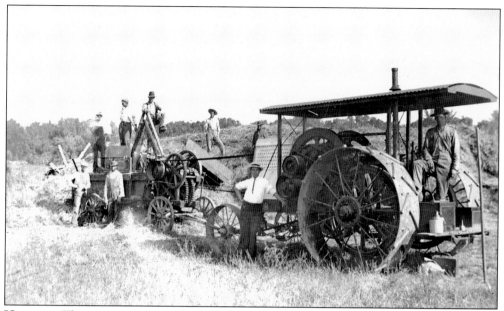

HAYWIRE. These men are out in the fields baling hay. Many times, those who owned this type of equipment moved from farm to farm working the fields. Sometimes neighbors helped each other; on other occasions, the owner of the machinery charged a set fee per acre or accepted hay in exchange for his labor. The photograph is dated August 30, 1910.

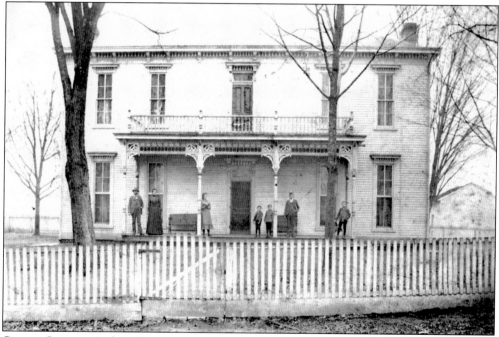

CRUMP CASTLE. Gathered on the porch of their home are, from left to right, Malcolm, Jennie, Mable, William, Embry, Dick, and Frank Crump. Their beautiful home was located in Smiths Grove. The house boasts a dentil cornice, beautiful hoodmolds over the windows, and an exuberant gingerbread porch. The second story of the porch is accessible from a center hall doorway and is surrounded with an attractive balustrade.

PAYING OFF A CHURCH NOTE. These men are stripping tobacco that they raised on an acre of land in the Smiths Grove area. Once the tobacco sold, the proceeds from "God's Acre" were donated to the Smiths Grove Methodist Church to help pay off a building note. The building, which contained education space, a kitchen, and a bathroom, was dedicated in 1947; it took three years to pay off the loan. The church used the same method to raise money for a parsonage in the 1950s. (Photograph courtesy of Mary Hurt.)

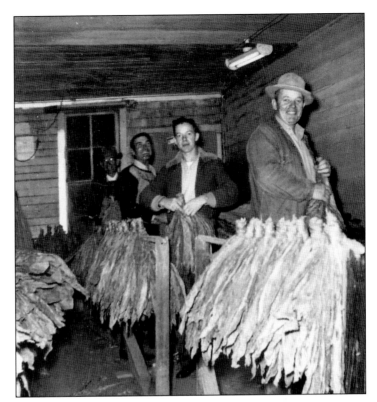

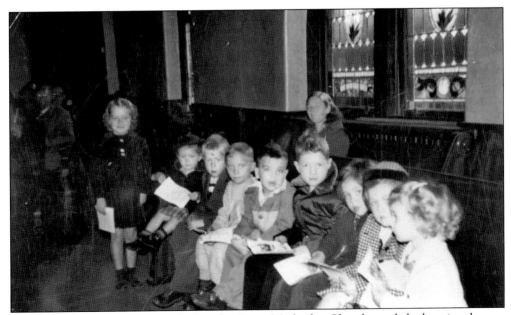

SUNDAY SCHOOL. One reason the Smiths Grove Methodist Church needed educational space was for children's programming. Here the children's Sunday school class is being held on one side of the sanctuary right below a set of beautiful stained-glass windows.

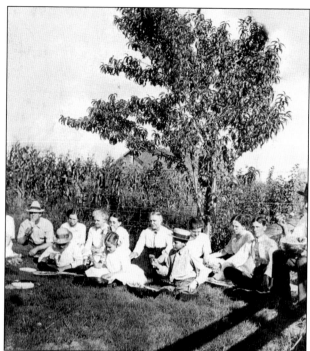

SUMMER DELIGHT. This family group is enjoying one of the warm season's most delightful occasions, the cutting of the first watermelon. Everyone seems pretty intent on avoiding the seeds and inhaling that fragrant pink meat.

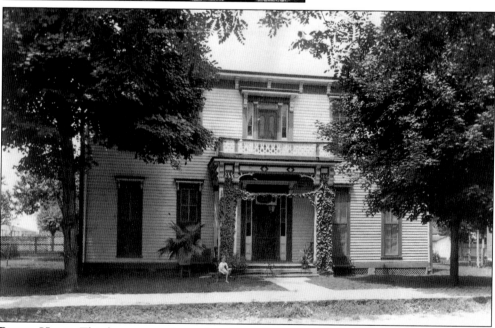

BEARD HOME. This home, once located on Main Street in Smiths Grove, is indicative of the agricultural prominence of northeastern Warren County. Richard E. and Mabel Kirby Beard lived in this two-story frame dwelling until 1922. Mr. Beard organized and managed a successful insurance office in Smiths Grove. The Beard abode boasted an exuberantly ornamented governor's porch. The boy pictured is the Beards' only son, William. Obviously Mabel possessed a green thumb; observe the tasteful vines meandering up the porch columns and the splendid potted palm behind William. The house was razed in 1973.

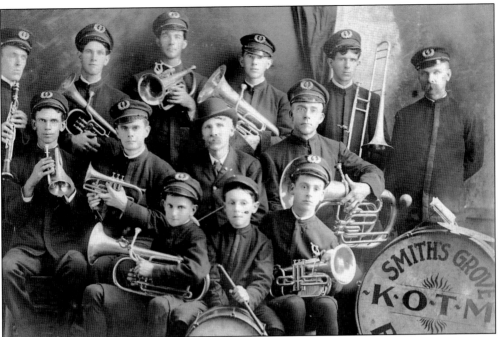

READY TO FACE THE MUSIC. This is the Smiths Grove cornet band on June 28, 1900. Although the musicians are not identified, a note attached to the picture indicates that five of them are Richeson family members. The group represented the Knights of the Maccabees, a fraternal and benevolent society that offered life insurance benefits to its members.

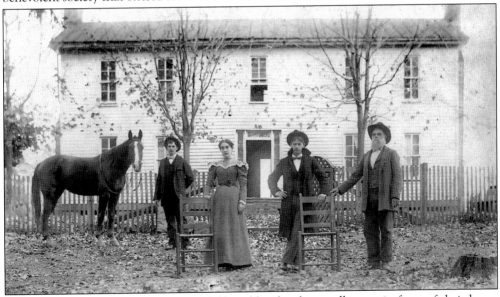

PROUD FAMILY. William Spencer (far left) and his family proudly pose in front of their home near Smiths Grove. The typical farmhouse has the doors on the first floor open and the center hall windows on the second floor open for cross ventilation. Having a horse in the picture is not uncommon in Kentucky, but the two empty chairs are unusual. They add a further degree of symmetry to this stark picture. The other people in this 1889 photograph are believed to be Susan Spencer, William's second wife, and his two sons Leander and Alonzo.

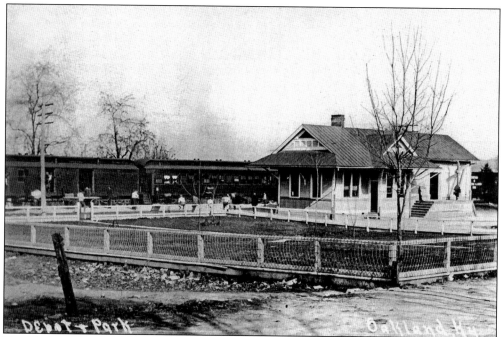

THE PLACE TO BE. The Louisville and Nashville Railroad built a depot in Oakland, Kentucky, in the late 19th century, and it appears on the 1877 Beers map of Warren County. The depot was a gathering spot for people, and the fenced area was known as Depot Park. This building was moved from Oakland in 1949, and the L&N discontinued all passenger service to that small town in 1958.

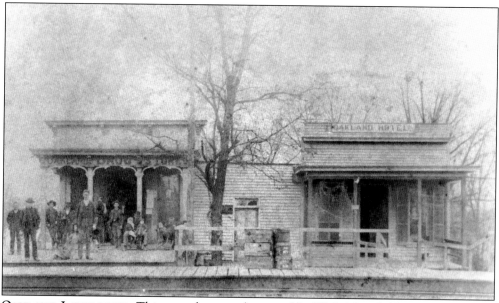

OAKLAND LANDMARKS. This rare photograph, owned by W. P. Mansfield Jr., shows the old Oakland Hotel and Oakland Drugstore. The two buildings were located on the northern side of the railroad track. Being this close to the track allowed for easy access but probably didn't permit sound sleeping.

50

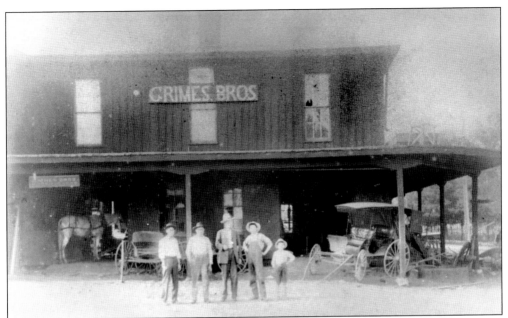

THE BUGGY SHOP. Also owned by W. P. Mansfield Jr., this photograph documents the Grimes Brothers buggy repair shop and stable. The almost unreadable sign on the left side also indicates that the Grimes brothers were undertakers for the Oakland community. In the 1895 state gazetteer, the Grimes brothers are listed as wagon makers.

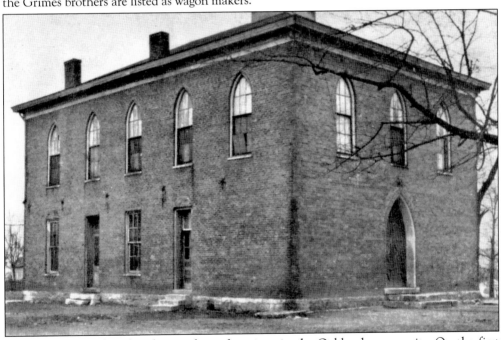

DOUBLE DUTY. This church served two functions in the Oakland community. On the first floor, the building housed Oakland's Christian Church. A teacher was allowed to conduct the Oakland School on the second floor. The masonry structure is believed to have been built as early as 1875; it was razed in 1925, and the bricks were salvaged and used in the new Oakland School south of town.

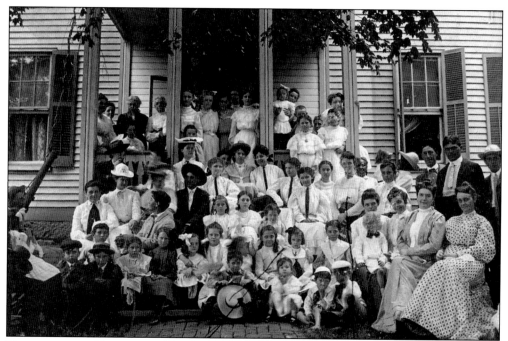

NEIGHBORHOOD GATHERING. Members of the Tucker and Amos families, along with others from the nearby vicinity, have gathered at the Dan Amos home in Oakland to pass away a summer evening in 1905. Everyone is certainly dressed for a party, and with the number of children present, surely this was a raucous day in the country.

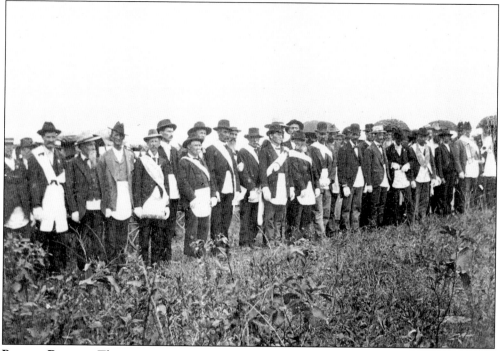

PROPER BURIAL. These men are participating in a Masonic burial ritual around 1900. This photograph is believed to have been taken in the Oakland area.

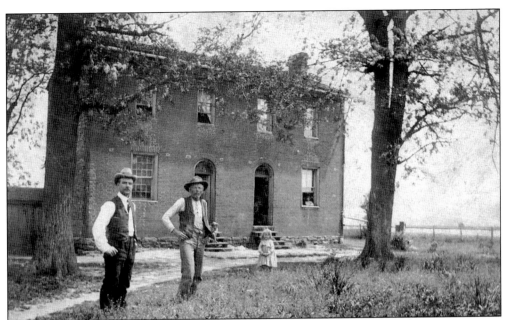

WILLIAM SMITH HOME. This lovely brick home was built in 1827 in the Oakland vicinity. The house features beautiful, arched double doors, a rough ashlar limestone foundation, and Flemish bond brickwork. Smith contracted Veet Patillow (sometimes Patilo) to do the masonry work on the house. Patillow, who was only 19 at the time, had been raised by the South Union Shakers and had learned brick making and laying under their tutelage. He learned his trade very well. The walls of the home were 13 inches thick.

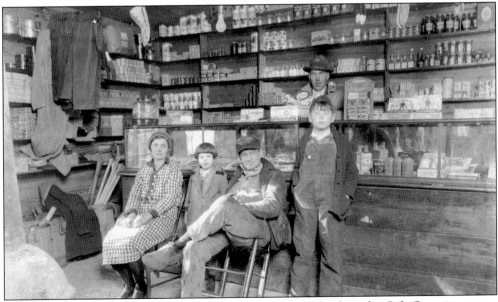

A THRIVING BUSINESS? It doesn't look like business is too brisk at the Cole Store just across the old College Street bridge from Bowling Green. General stores were common meeting places for locals. Along the photograph's left margin, a portion of the old potbellied stove is visible; it would prove a popular place on a cold day. Notice the gloves and stockings hanging from the ceiling; a package of salted peanuts was only a nickel.

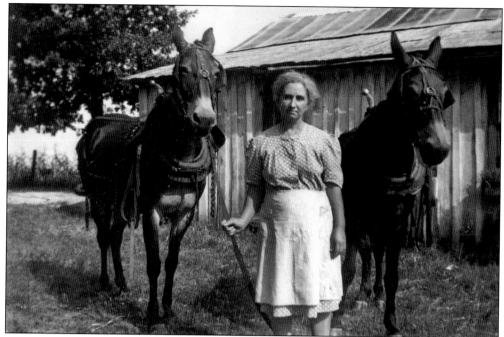

A WOMAN AND THE FAMILY MULES. It was not uncommon for rural families to name their work animals, particularly mules and horses. Vadie (Howell) Ground is seen in the Three Forks neighborhood with the family's two mules, Alex (left) and Katie. The family's board-and-batten home can be seen in the background. (Courtesy of Sue Lynn McDaniel.)

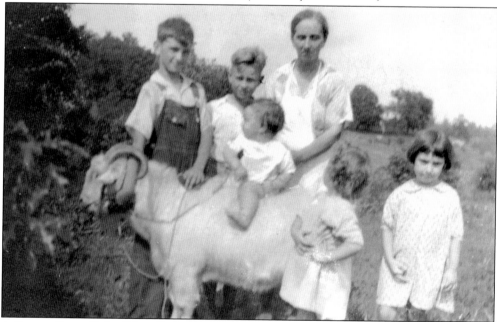

A BUMPY RIDE. Vadie (Howell) Ground (center) allows the baby to take a ride atop the family goat, Tom, on the Ground family farm in the Three Forks neighborhood. The children are, from left to right, Maxie Ground, Douglas Hays, Bill Ground (on the goat), Madell Ground, and Mildred Beckham. (Courtesy of Sue Lynn McDaniel.)

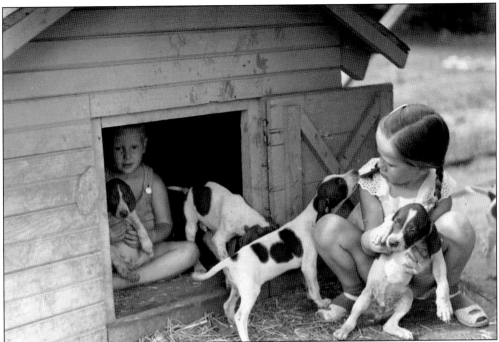

IN THE DOGHOUSE. Children all over Warren County love animals, and who could resist these bird dog puppies? Certainly these children can't. The young lady, however, is a little perturbed that one puppy is mussing up the pretty eyelet trim on her blouse.

PICKING POSIES. With the plowmen looking on, a family has come out to pick flowers before the field is turned under. Perhaps the children are gathering their May Day bouquets. On the first day of May, children traditionally left picked flowers on the front stoop; they then knocked on the door and quickly ran away in hopes that the lady of the house would not spy the donor of the springtime bouquet.

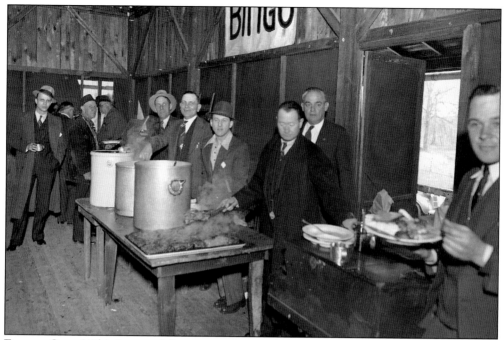

EATING CROW! This is part of the serving crew at the Black Crow dinner held at Beech Bend Park on March 12, 1939. The menu for the august occasion included "black partridge" stuffed with dressing, gravy, baked potato, slaw, and coffee. These meetings were held for several years to culminate a regional-wide crow-shooting contest.

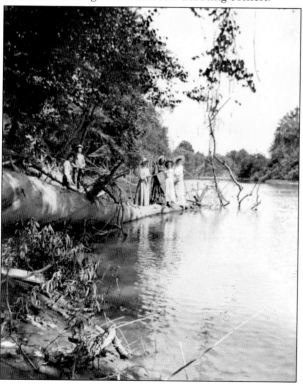

EARLY AMUSEMENT AREA. The Black Crow dinner pictured above took place in the pavilion at Beech Bend Park. The Brashear family named the park for the native beech trees found along a bend of the Barren River. In this vintage photograph, Beech Bend guests are out for a day of fishing. The park opened in 1907 for dancing, skating, fishing, and swimming in the Barren River. The Brashears sold the property to Charlie Garvin in 1942, and he proceeded to turn it into one this region's most successful amusement parks. Admission was one dime. Attractions included rides, a zoo, a camping area, swimming, miniature golf, and games of chance.

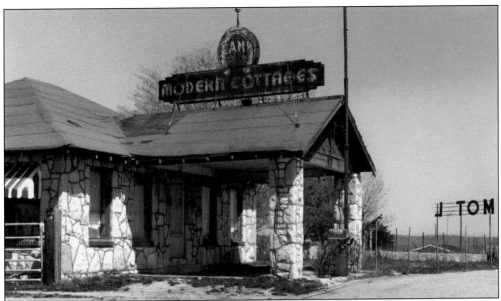

HORSING AROUND. In the early 1930s, J. L. Cornwell added gas pumps and four tourist cabins to his beer tavern located on U.S. 31 West between Bowling Green and Smiths Grove. Previously Cornwell had rented campsites to travelers. In the mid-1930s, more cabins were added, and the Cornwells changed the complex's name from Horse Shoe Camp to Horseshoe Cottage Court. The property was later owned and operated by P. L. and Kathryn Forrester, who converted the tavern into a packaged liquor store. (Photograph by Joerg Seitz.)

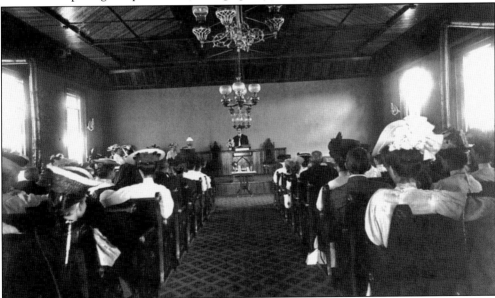

THE BEAUTY INSIDE. Mount Olivet Cumberland Presbyterian Church is the oldest church of its denomination in Warren County. It was organized in 1813, the result of revivals during the second Great Awakening. The revivals were held in brush arbors on the present church property. This rare interior photograph shows a church service about to take place at Mount Olivet. The beautiful beaded board ceiling, elaborate light fixtures, and handsome pulpit furniture indicate the prosperity of this ancient church. (Courtesy of Mount Olivet Cumberland Presbyterian Church.)

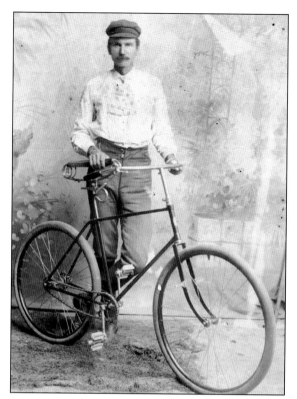

VICTORIAN BICYCLIST. It was not uncommon to find bicycles in rural areas after 1890, when the safety bicycle was invented. By then, bicycles had pneumatic tires, safety brakes, and were at a respectable height. With a protective net over the back wheel and a dropped middle support bar, even women could be found riding the two-wheeled wonders.

IN MEMORIAM. Infant deaths were a common occurrence. Some families waited months before they even named a child for fear they would get too attached to the baby. Close observation in any rural cemetery will tell the sad story of high infant mortality rates.

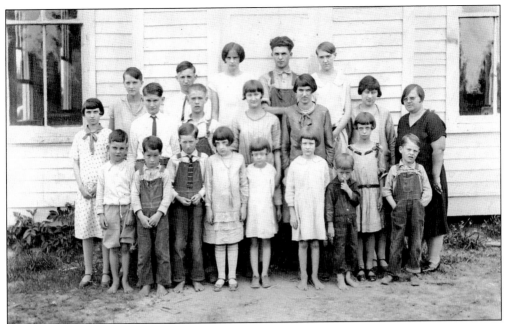

READING, WRITING, AND ARITHMETIC. The students from the one-room school at Walnut Grove are shown here with their teacher, Pearl Hargis (adult on the far right), in the mid-1920s. The school was located on Howell Road between Middle Bridge and Greathouse Roads. The school caught fire and burned to the ground on October 27, 1944, as the children were preparing for a Halloween party. (Courtesy of Sue Lynn McDaniel.)

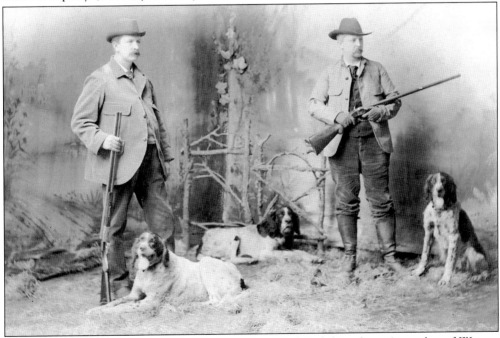

HUNTERS. These men obviously hunted for sport and loved their dogs. A number of Warren County residents have bred dogs for their personal use and for sale. Here I. B. Cook and W. H. Jones pose with their bird dogs.

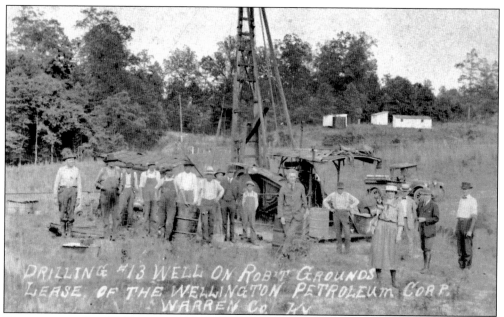

HUNTING FOR OIL. Wildcatters are shown getting ready to begin drilling on the Robert Ground lease. Many Warren County families leased their land for a percentage of the potential proceeds from oil that might be found on their property. Few made much money, but some productive areas—such as the Moulder and Davenport fields—did yield handsome profits.

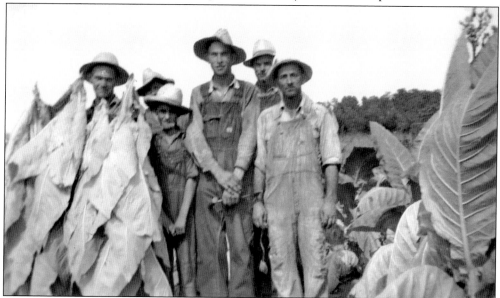

CUTTING THE WEED. These men are out in late August cutting the tobacco and sticking it. Tobacco leaves are hand cut and then pushed down a slender stick so that the tips of the leaves hang down. The sticks are then evenly spaced along boards hung from the rafters of barns. In South Central Kentucky, burley tobacco is air cured. Less then 100 miles west of Warren County, dark tobacco is smoke cured. Tobacco cultivation is very labor intensive, and in days gone by, people could pretty much set their calendars by each of the processes: preparing the bed, planting, topping, cutting, stripping, and selling. (Courtesy of Jackie [Elkin] Chaffin.)

Three

NORTHWEST WARREN COUNTY

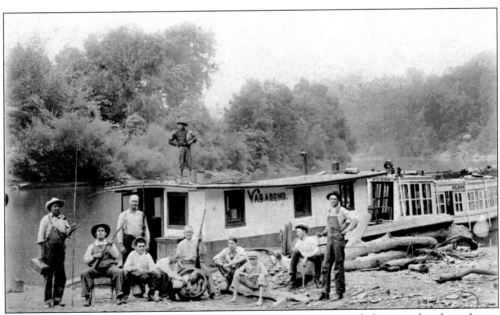

SPORTING MEN. These Warren County gentlemen are out for an extended stay on their houseboats, the *Vagabond* and the *Filson*. The African American boy atop the boat is unidentified, but the other men include J. Porter Hines, John Rochester, E. R. Hines, Arch Wilkins, Everett Overstreet, and Frank Noland. The photograph was taken in 1913 just below lock number five on the Green River. Obviously the men are out on a hunting and fishing expedition.

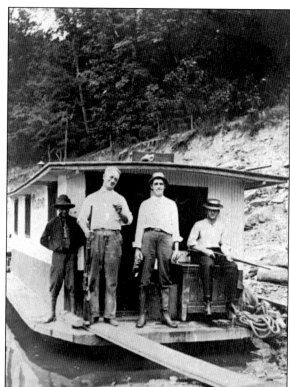

MOTLEY CREW. Houseboats were once quite common on the Barren and Green Rivers, and the *Vagabond* frequently plied these waters. On board are, from left to right, an unidentified African American boy, Arch Wilkins, Ed Hines, and J. Porter Hines. Houseboats were used chiefly for pleasure trips but could come in handy for river men as temporary homes.

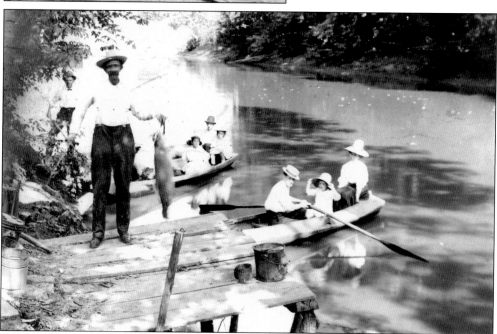

WHAT A CATCH. Blessed with many creeks and rivers, Warren County affords great fishing. Jim Newton has just pulled in a whopper from the Gasper River. The people in the boat behind Newton include Markham Hines (standing), J. Porter Hines, Louise Hines Moss, Jane Morningstar, Ida Hines Waller, and Will Taylor. The people in the boat in the foreground are no identified.

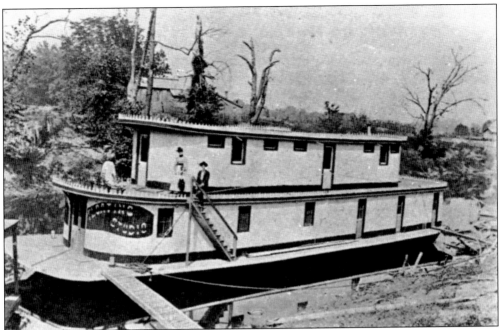

SMILE PLEASE. The Schroeter Floating Studio plied the Green River from 1890 to 1920 searching for those who wanted their portraits made. The boat was not a steamboat; it was moved from place to place by towboats. Henry O'Neil Schroeter (1862–1943) was born to Swiss immigrants in Evansville, Indiana. He eventually settled in Hartford, Kentucky. More than a few Warren Countians had portraits made by Schroeter, who was known as the "artist of the emerald wave."

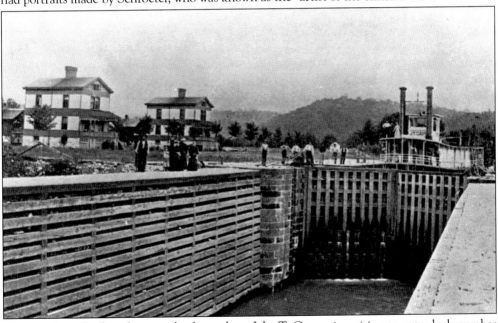

LOCKED OUT. In this photograph, the tugboat *John T. Carson* is waiting to enter lock number one on the Barren River at Greencastle. To the left of the lock are the government-owned houses in which the lockkeepers lived. This lock was completed in 1845 by James Ford and Thomas Stephens Sr.

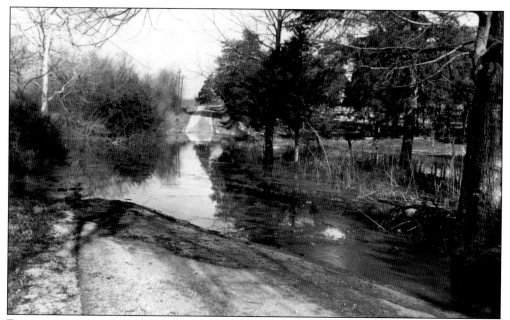

FLOODED. Periodic flooding of low-water bridges was a typical occurrence in the county prior to the 1950s. This photograph shows Jennings Creek a good three feet above the bridge on Glen Lily Road. Jennings Creek is known as one of the only waterways in Warren County that is cold enough to support a habitat of trout. This cool water is the result of it coming from the underground Lost River Cave system. (Photograph by Ches Johnson.)

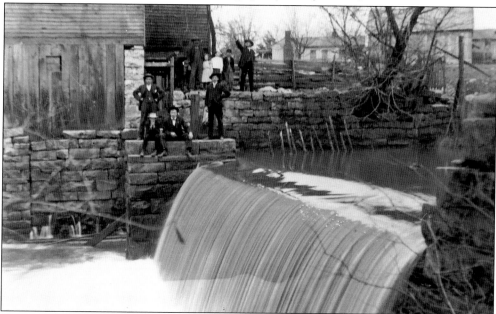

DISHMAN'S MILL. Joe Ennis constructed this dam and gristmill on Jennings Creek about a mile northwest of Bowling Green in the late 1840s. Soon thereafter, Harvey Dishman (1823–1891) purchased an interest in the mill, and his name was indelibly linked to the site. The mill continued in operation until around 1915. Those pictured are from several families who lived along the Glen Lily Road not far from the mill.

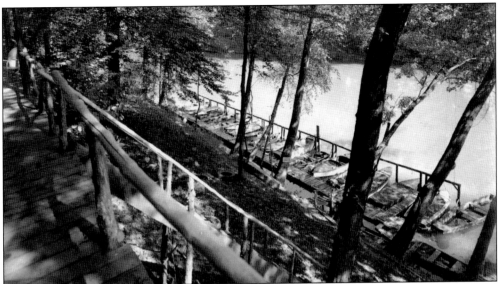

READY TO LAUNCH. McFarland's, operated by Mr. and Mrs. Robert McFarland, was a popular place to launch a boat for a leisurely day on the Barren River. Fun-loving folk from Bowling Green went out the Barren River Road and then turned onto McFarland Lane near the old quarry. At McFarland's, one could sit in an outdoor booth and enjoy an ice-cold drink or swim along the riverbank. A pavilion equipped with a jukebox was a favorite place to hang out, even after dark, and dance the night away.

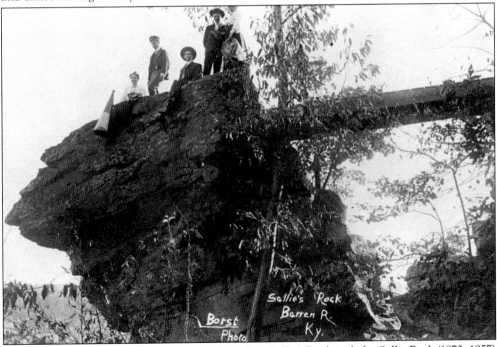

ROCK BAND. This photograph of a group of people at Sallie's Rock includes Sallie Beck (1873–1957) at the left. The rock, 198 feet above the water and located near the confluence of the Green and Barren Rivers, leaned precipitously away from the bluff. Using her megaphone, Sallie beckoned to passengers and crews of passing steamboats. (Photograph by Borst.)

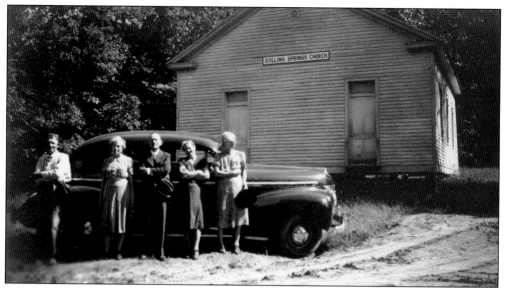

ROLLING SPRINGS CHURCH. This Methodist church, located near the Guy community, was constituted in 1887. It is named for a nearby spring that rolls by the church. J. T. Jones donated the land for the church in March 1887, and the pictured building was erected soon afterward. A log building underneath has been covered with clapboard siding, but salient features such as the two front doors have remained.

SCHOOL REUNION. This photograph, taken in July 1952, includes the former students of the Rolling Springs School gathered for a homecoming at the school site. John Maxey donated two acres for this school in 1895, and a building was erected that year. When the school census was taken in 1909, the Rolling Springs School had 64 pupils enrolled, with an average attendance of 32.

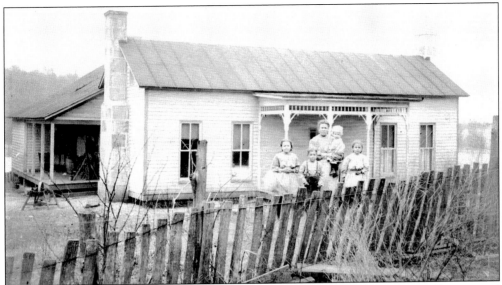

THE YOUNG CLAN. Posed in front of their new house from left to right are Ret, Roscoe, and Hattie Young (holding boy), along with friends James Allen (baby) and Vessie Elkin. The new home near Riverside was built in front of the old home place, a portion of which can be seen toward the left margin. Their fashionable abode features a standing seam metal roof, matching cut limestone chimneys, two-over-two double-hung windows, and a fanciful front porch complete with gingerbread.

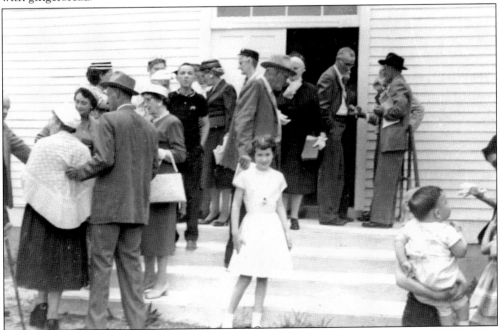

VISITING. Church members linger outside Price's Chapel Church around Easter 1960. This church was built in the late 19th century on land donated by John C. Westbrook (1845–1924). A Westbrook descendant described the pews as "very hard" and attached to the walls with a central aisle. The church burned in the early 1990s during a rash of fires that destroyed four other church buildings in Warren County.

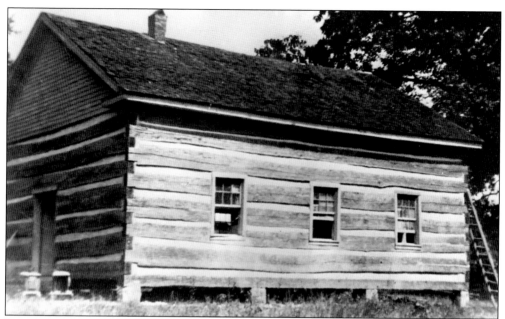

LOG CHURCH. Highland Baptist Church was constituted in 1878 and met in this log structure for many years. The poplar log building was destroyed by fire on March 9, 1939. It reportedly caught fire when someone was burning off a tobacco field. The church met in a member's home the next week, and a motion was made to erect a new building. While funds were solicited, the church met in a school bus parked on the church grounds. The new stone church was formally dedicated on May 22, 1940, with Dr. R. T. Skinner of Bowling Green's First Baptist Church giving the sermon. The members packed the church for dedication services and stayed for dinner on the grounds afterward. The church chose to use two front doors, a custom that had slowly faded from favor. In the previous two centuries, two separate front doors were constructed for the two genders. Adjacent to the church is a substantial cemetery.

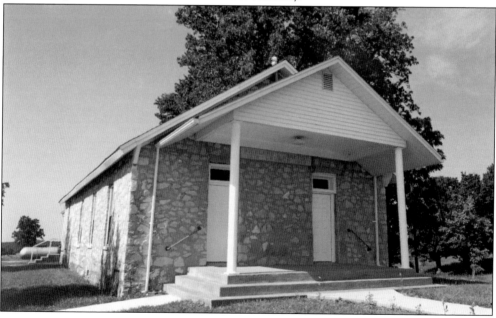

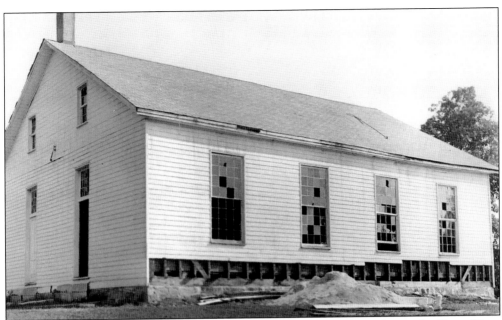

DISABLED. The late-1950s photograph above shows a restoration taking place at the Green River Union Meeting House near Richardsville. The congregation consisted of several Huguenot families that migrated to northwestern Warren County around 1814 from Buckingham County, Virginia. Constructed around 1845, this building featured yellow poplar framing. Three, 14-inch-square, hand-hewn posts supported a ceiling beam that ran the entire length of the building. A reporter for the *Daily News* claimed in 1959 that the walls were still plumb and square. The large sanctuary was girdled with a lovely beaded wainscoting, and the pews on the outer rows were attached to the walls. The photograph below shows the interior in the mid-1960s. Used only on special occasions, the church fell into disrepair and was razed in 2004. The church was situated on a large hilltop outside Richardsville and had a commanding view of the surrounding countryside. A large cemetery remains on the hill.

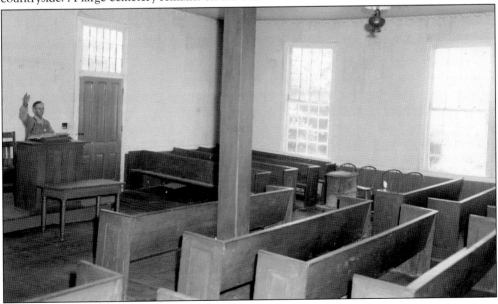

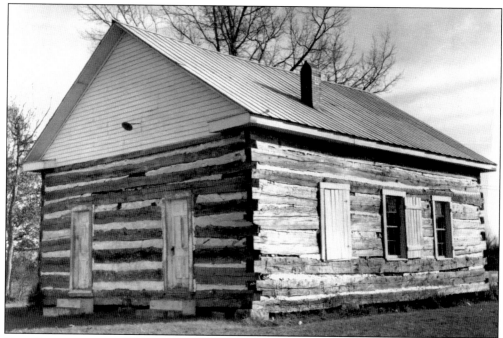

THE CHURCH IN THE WILDWOOD. The Oak Forest Baptist Church, near Riverside, was said to have been completed on March 5, 1879. William Slyvestor Young gave the property for this church in 1883. The deed states that the land included "a church house now standing." Clapboard siding now covers the oak and poplar log structure, but the logs are visible inside. Some of the timbers are up to 40 feet long.

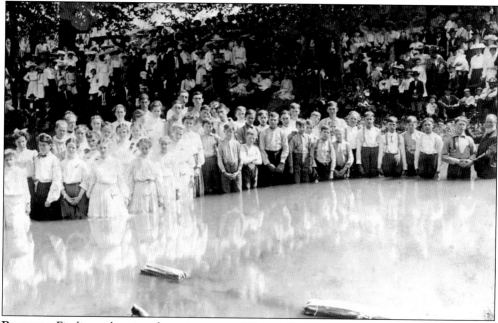

BAPTISM. Finding a baptismal service site in Warren County was not difficult, as the area is blessed with many streams, lakes, rivers and ponds. Only extreme weather prevented the event from taking place. Here a congregation gathers to witness a baptism in 1905.

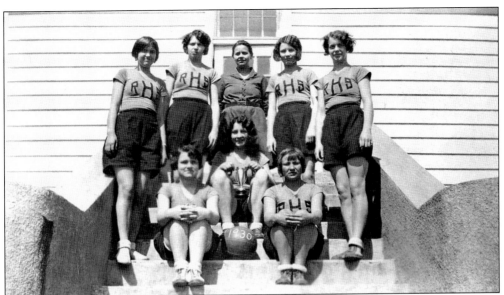

RICHARDSVILLE HOOPSTERS. Sports enthusiast Nonnie Young—who at one time played basketball for WKU—coached these young ladies from Richardsville in 1930. Young taught at the Richardsville School for many years. Pictured, from left to right, are the following: (first row) Alyene Whalin, Maude Young, and Lannie B. Meadows; (second row) Matilee Elkin, Willodean Miller, Nonnie Young, Madge Trice, and Orvene Whalin.

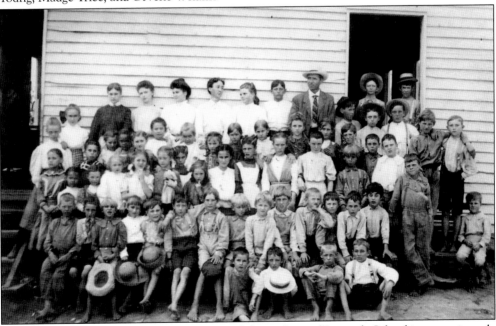

SCHOOL DAYS. This photographer has captured the students of Riverside School in approximately 1909. Notice the number of hats and bare feet in the crowd. The land for this school was sold to the trustees in August 1884 by William Burris; the deed stipulated that the school would enjoy access to a nearby spring for water. A 1909 school census indicated that this school's district had 109 children of school age; 88 children were actually enrolled, and the average monthly attendance was 57.

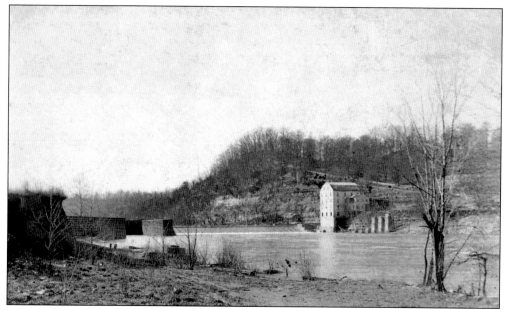

BROWN'S LOCK MILL. The Barren River Lock and Dam No. 1, built at Greencastle, was sometimes referred to as Brown's Lock because of the large, four-story mill built there by Capt. William Brown. It was believed to have been constructed around 1850. The mill ground wheat and corn and also housed a woolen mill.

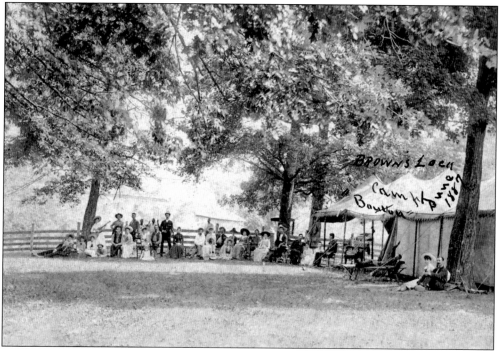

MILLING AROUND. These lounging Victorians have come out from town to relax near Brown's Lock. The tent indicates that some of the group are actually camping out; others probably joined them for brief respites that didn't require overnight lodging. Looking closely at the crowd on the left side of the photograph, notice a lone woman with a guitar serenading the group.

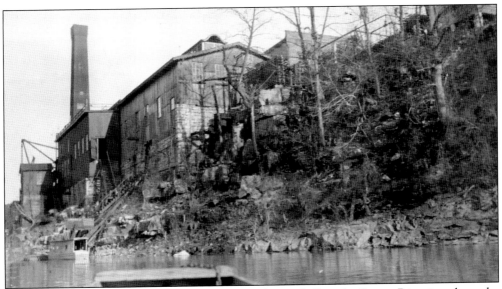

A REAR VIEW. This unusual photograph is taken from a skiff on the Barren River just above the boat landing. The bow of the boat can be seen in the foreground. The behemoth facility directly ahead is the old Bowling Green Ice and Cold Storage Company founded by John A. Robinson (1824–1892) and E. B. Seeley (1825–1902) in 1888. Initially the plant turned out 15 tons of ice per day, but with improvements, the operation produced 100 tons per day by 1924.

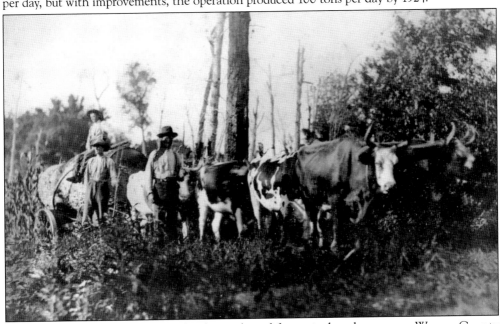

LUMBER MAGNATES. Even after land was cleared for agricultural purposes, Warren County farmers cut timber on their land or sold timber rights for profit. Chestnut, oak, hickory, and other hardwoods were at one time quite plentiful, as well as towering poplar trees. Much of the native hickory was used by the old Turner Day Woodworth Axe Handle Factory in Bowling Green. Tremendous rafts of logs were also floated downriver to Evansville, Indiana, where the timbers were cut for flooring. The men in the photograph are using eight oxen to pull a behemoth log out of the forest near the Green River.

CHERRY HOMESTEAD. Pictured here are 8 of the 10 sons born to George Washington (1822–1911) and Frances Martha (Stahl) Cherry (1832–1919). One of the sons, Henry Hardin Cherry (1865–1937), went on to become president of WKU; another, Thomas Crittenden Cherry (1862–1947), became superintendent of Bowling Green's school system. The photograph shows the ancestral log home and the family's later frame house, which was located near the Halls Chapel Methodist Church.

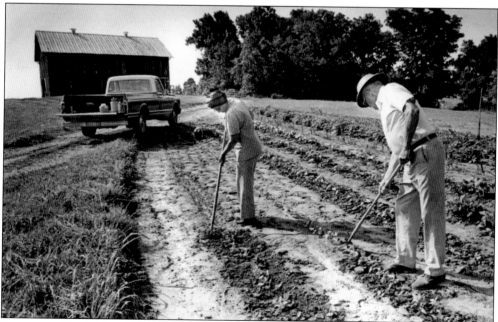

LIFT THAT HOE! This farming couple is weeding and aerating the soil in their truck garden. Looming in the background is their tobacco barn. Notice the woman's humorous headwear. Easily discernible are beans, onions, lettuce, and potatoes. The family dog waits for the gentleman at the end of his row. (Photograph by Mark Workman.)

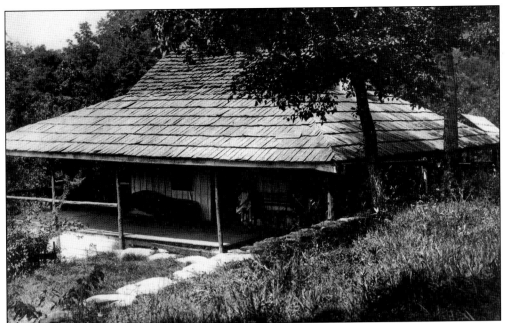

GASPER RETREAT. The unusual architecture of this home is reminiscent of lower Louisiana. The high-pitched roof protects the main block of the house, while the wonderful flared section covered a large wraparound porch. Located on a natural high spot near the Gasper River, the cottage's porch afforded a commanding view of the surrounding countryside. Bowling Green attorney Edward Ludlow Hines (1842–1920) owned this charming cottage of board-and-batten construction.

A COTTAGE WITH A VIEW. This panoramic landscape was one of the scenes visible from Edward Hines's cottage (pictured at top). This bucolic scene features the bridge located where the Barren and Gasper Rivers meet. The Gasper River is about 25 miles long and from 40 to 60 feet wide. Its rapids, rocky shore, and surrounding timberland make the Gasper a beautiful canoeing river.

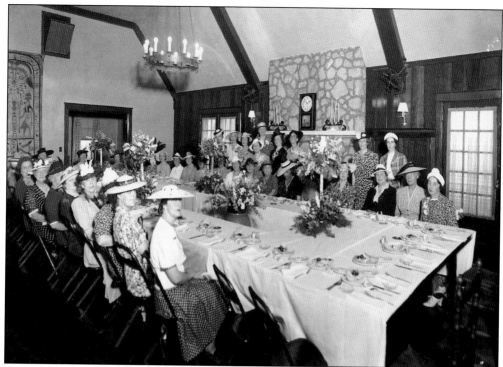

CHAPEAU EVENT. These ladies are the guests of Ruth Rabold (1901–1986) and Jeanne Moss for a luncheon at the old country club on Richardsville Road (Highway 185). This building burned in October 1929. Notice the fans mounted on the wooden beams and the odd Egyptian wall hanging on the far left margin. The flowers and hats are lovely.

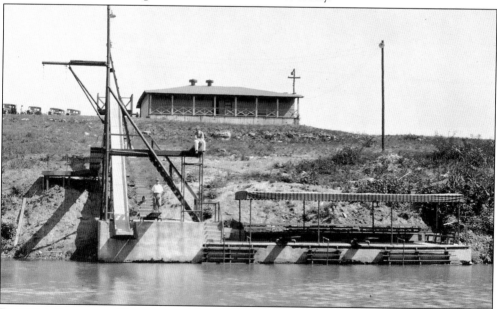

DIGNIFIED SWIMMING. The country club on Richardsville Road boasted a very nice eating pavilion on the river as well as a slide, diving board, and swing that allowed direct access to the water. Not far away was a floating barge for those brave enough to swim out to the center.

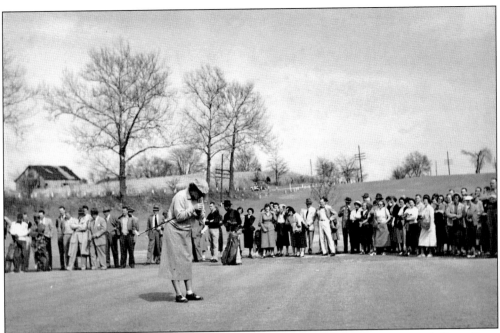

WATCHING THE PRO. A large group of men and women have turned out to watch Patty Berg, a professional golfer representing the Wilson Sporting Goods Company. She provided tips for golfers at the Bowling Green Country Club in the late 1940s. Berg turned professional in 1940 and won 57 tournaments on the LPGA tour during her career.

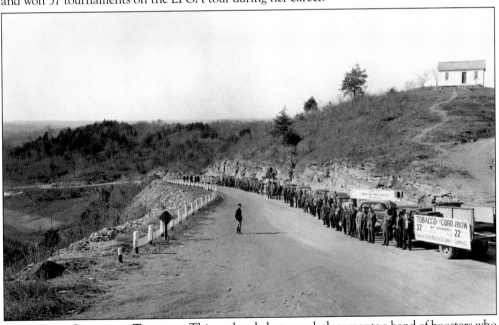

PROMOTING CORN AND TOBACCO. This undated photograph documents a band of boosters who are out scouring the northwest section of the county to promote the Tobacco and Corn Show to be held in Bowling Green on December 11. These tours went to areas where farmers might be inclined to take their tobacco to other markets such as Morgantown, Glasgow, or Cave City. Based on the age of the cars, it looks like this photograph was taken in the 1930s.

WINTER WONDERLAND. This photograph was taken around 1900 as members of the Hines family make the trek to their getaway cabin on the Gasper River. (Courtesy of Cora Jane Spiller.)

A POLITICAL BOAT RIDE. These politicians aboard the steamboat *Nolin* have just returned from touring the nearby Kyrock asphalt plant. From left to right are (seated) Sheriff Bodley Davenport, Gov. A. B. "Happy" Chandler, Alton Mitchell, and Bob Humphrey; (standing) Henry T. St. George Carmichael, Highway Commissioner Emory Dent (1878–1945), County Attorney William Natcher (1909–1994), and Cecil Williams.

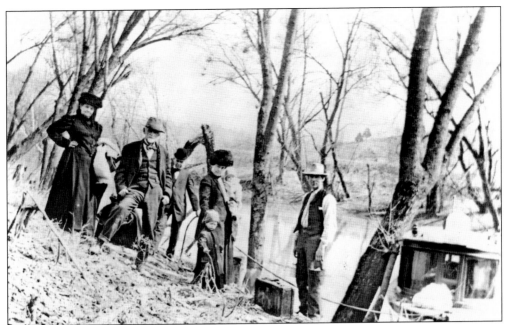

TOURING. This group is obviously making a trip to Bowling Green or some other exotic location down river. The people are, from left to right, Mrs. Riggs, Capt. Edward Ludlow Hines, Henry Fitch (in the bowler hat) (1874–1959), Stella Fitch (1875–1964) holding Lindsay Fitch, Henrietta Fitch, and Carl Riggs. (Courtesy of Cora Jane Spiller.)

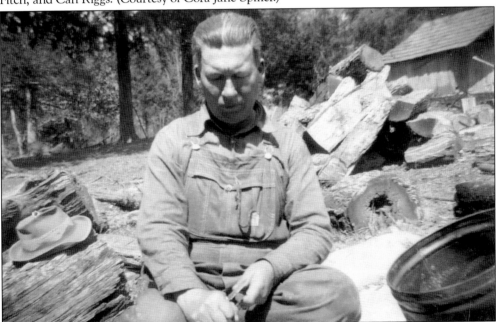

WOODWORKER. With intense concentration, Edward D. "Boss" Jones (1900–1981) whittles a stick out by the woodpile on his Anna farm around 1945. Cutting enough wood for the fireplace or stove was a perennial task, and there were always plenty of trees available. Farmers were constantly clearing land on their property for crops, which made for plentiful woodpiles. Dying trees might also be cut for firewood. (Courtesy of Dennis Jones.)

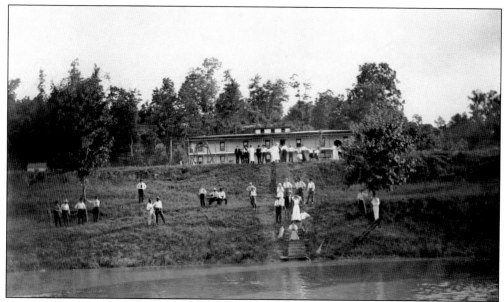

HOTEL MASSEY. This 40-room hotel was located on the Green River near Honakers Ferry. It opened in the late 19th century and remained a popular summer resort until 1914. Guests from Evansville, Louisville, Owensboro, and Bowling Green reached the hotel by steamboat. Pictured is the resort's river landing. The hotel was similar to other resort structures built around the country, with all doors opening onto porches. (Courtesy of Barbara Ford.)

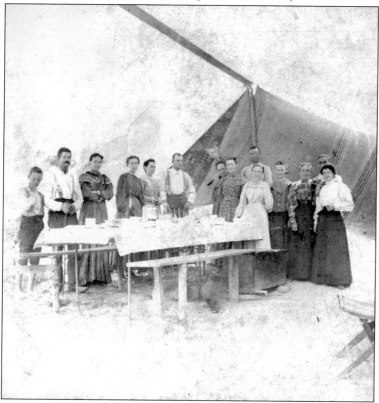

PICNIC UNDER THE BIG TOP. This group is picnicking under a huge tent at Massey Springs in July 1898. Part of the tent is actually made from old quilts. Massey Springs offered hotel facilities, but many people preferred to camp out. The tent protected them from the elements, particularly the sun.

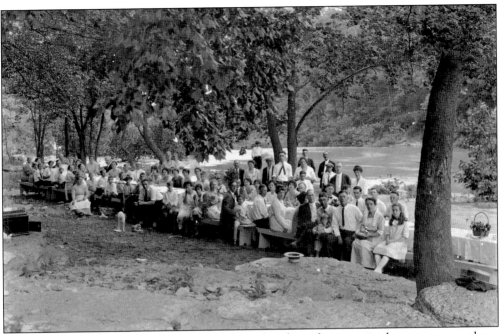

CREEKSIDE DINING. It was not unusual to picnic beside cool streams in the summer months—anything to help cool down. This appears to be a church group eating after services. The box seen on the photograph's left margin is not a stove; it may be a phonograph. No more pleasant a day could be spent then dining by the waterside and listening to music.

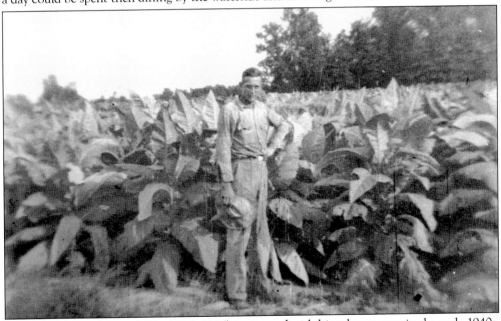

STANDING TALL. Myron Elkin (1912–1986) is pictured with his tobacco crop in the early 1940s. Besides tobacco, Elkin raised beef cattle, dairy cattle, corn, hay, pigs, and sometimes barley on his 269-acre farm near Benleo. Although tobacco culture has diminished in South Central Kentucky as farmers have diversified their farms, the statuesque weed remains an important cash crop. (Courtesy of Jackie [Elkin] Chaffin.)

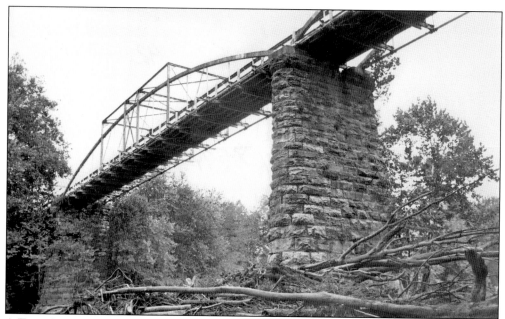

A TALL ORDER. The Richardsville Road Bridge, built in 1889, spans the Barren River on Highway 185, once one of the principal access routes to Warren County's northwestern section. The bridge consists of a triple span Bowstring Arch Truss with a light through truss added to the center of each span. The bridge was restored in the late-1980s by David Garvin and is listed on the National Register of Historic Places. (Photograph by LaMar Weaver.)

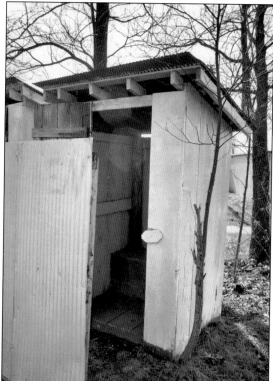

THE NECESSARY. This is the men's restroom at Lewis Chapel United Methodist Church in Hadley in the winter of 1995. Soon afterward, the church constructed an addition to their building that included new facilities. Many people remember having to brave the elements to take care of business during prolonged church services. The women's facility was located adjacent to the men's. (Photograph by Jonathan Jeffrey.)

Four

SOUTHEAST WARREN COUNTY

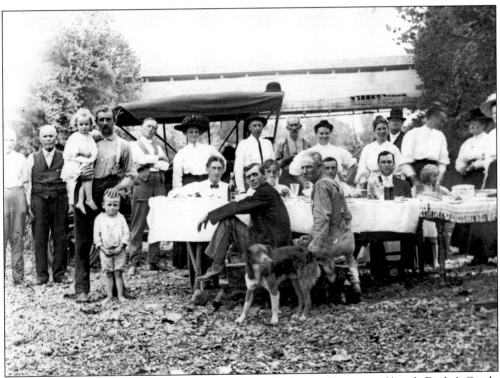

WATERSIDE PICNIC. This august group has set the table for an alfresco meal beside Drake's Creek. The covered bridge crossing Drake's Creek was on Old Scottsville Road at Sweeney's Mill about one and a half miles east of Greenwood. The group includes members of the Ennis, Merriman, Ham, Basham, and Wright families.

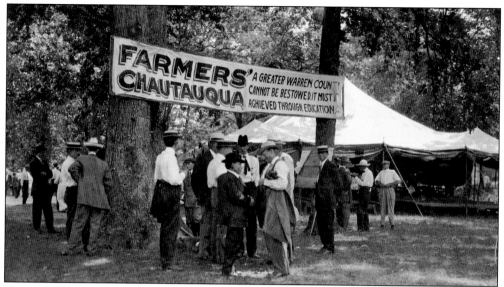

FARMERS' CHAUTAUQUA. With the religious fervor of a true Progressive, Dr. Henry Hardin Cherry (1865–1937), president of WKU, launched a series of rural meetings in Warren County to purvey the latest data concerning scientific farming, rural education and sociology, improved sanitary methods, and personal hygiene. Held in 1913, this particular meeting took place in Plano. (Courtesy of University Archives, WKU.)

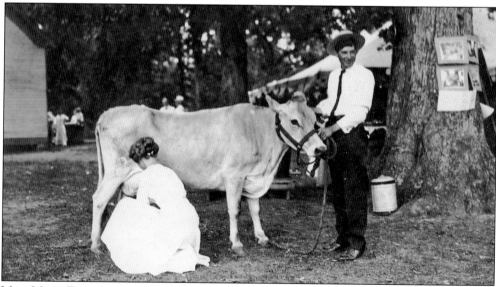

MILK MAID. Demonstrations were an important component of the chautauqua program. A young woman milks a fine cow in order to provide the milk necessary for tests that were conducted on site. Women also participated in programs concerning decoration of the rural home, family health and hygiene, food preservation, cheese production, cooking, and sewing. (Courtesy of University Archives, WKU.)

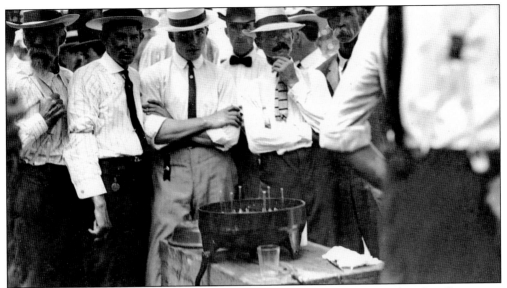

SKEPTICS. These men are gathered around an apparatus known as the Babcock milk tester, a mechanism used to determine the fat content of milk. Other popular demonstrations included an acid test used to determine a soil's lime content, pure water tests, hog cholera vaccinations on animals, and correct pruning techniques. Attendees also participated in contests that measured speed in plowing, saddling and harnessing horses, relay races, and spelling bees. (Courtesy of University Archives, WKU.)

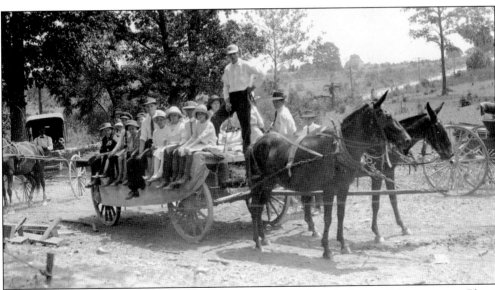

FREE AT LAST! These school children are being transported to the farmers' chautauqua at Plano via a wagon pulled by mules. During the four-day event, classes were customarily dismissed so that the children could attend sessions with their parents. Consolidation of the many one-room county schools was one of Dr. Cherry's chief goals in holding the series of rural meetings. He brought in several regional speakers to address the issue. (Courtesy of University Archives, WKU.)

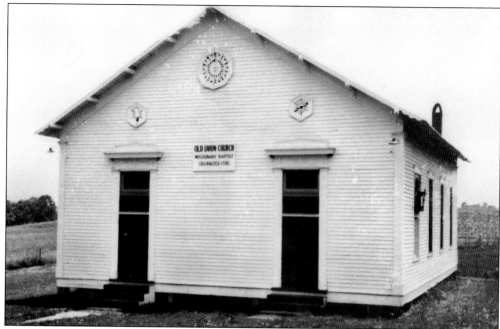

OLDEST CHURCH. The Old Union Church, between Plano and Woodburn, was constituted in 1795, making it one the oldest churches in the county. Like many early churches, their first building was shared by several denominations. The building pictured here was erected in 1866. The congregation, which is Baptist, flourishes today and has a large modern facility, cemetery, and school.

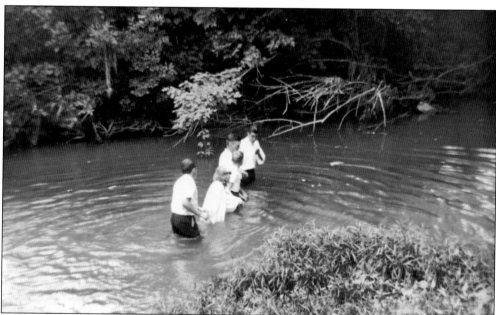

BAPTISM. These congregants did not have to go far to find the baptismal waters. Bays Fork Baptist Church members are seen here at the Railey Ford on Bays Fork in 1964. Participants are, from left to right, Stephen Sledge, Elaine Sledge, David Hardcastle, Mitchell Hardcastle, and Pastor L. O. Deweese. (Courtesy of Laurita Sledge.)

FROM SUNUP TO SUNSET. This rural scene features the bright sun in the foreground with the pale moon rising to take the preeminent position in the sky. While these astronomical changes take place, a farmer disking his land fights time in order to get his work done. (Photograph by Mark Workman.)

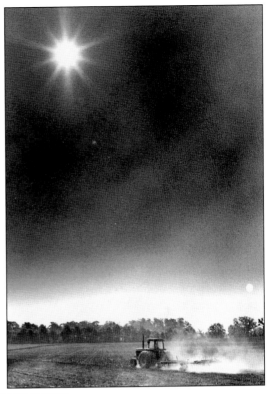

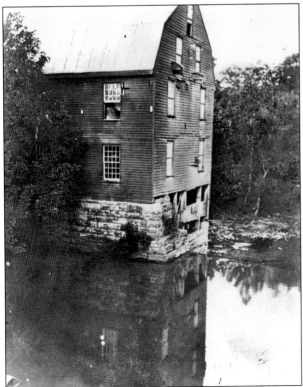

MASSEY MILL. Located 12 miles south of Bowling Green on Drakes Creek near the Scottsville Road, Massey Mill stood from around 1848 until it burned in April 1928. It was originally built by Jim Skaggs and was said to have been one of the largest water-powered mills in this section of the state. The building was constructed of yellow poplar. The site was also one of the area's prime fishing spots.

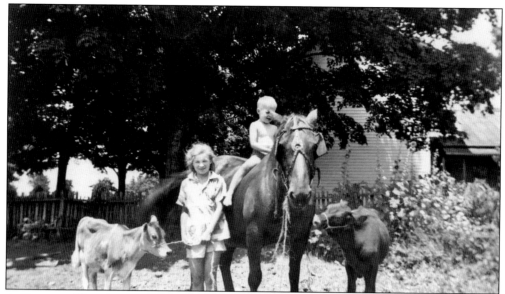

A Girl and Her Animals. Alicia Joan Howell is show amongst her menagerie on the Homer Howell farm in the Motley vicinity. Included is little brother Danny Howell atop the family mare, Old Nell, and two of their cows, Becky (on the left) and Betty. When Alicia joined 4-H, she used Becky as her project animal and showed her at demonstration events and fairs. She won several showmanship ribbons for her work and admitted that feeding Becky white bread aided her efforts. (Courtesy of Alicia [Howell] White.)

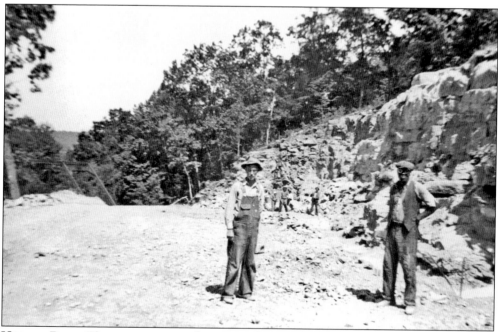

Hit the Road. These men are part of a team working on roads in southeastern Warren County near the Allen County line. They had quite a job carving through hilltops, as pictured here in the 1930s.

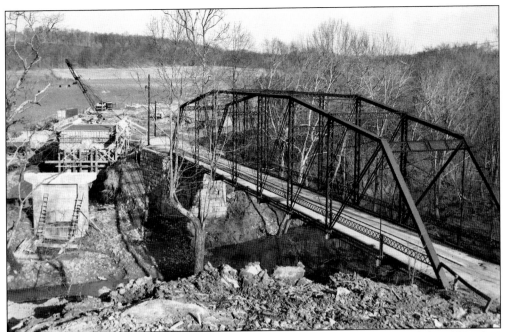

BRIDGING THE GAP. Taken in June 1963, this photograph shows the new and the old bridges spanning Drakes Creek on Highway 240. The new bridge was constructed by the T. C. Young Construction Company. The old bridge is very similar to the old College Street bridge in Bowling Green. Notice the substantial limestone pier supporting the older bridge. (Photograph by Ches Johnson.)

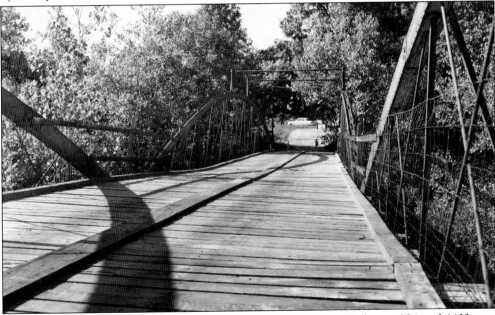

CLOSED. The old bridge, located on Iron Bridge Road between Highways 234 and 1402, was determined to be unsafe for vehicular traffic in the mid-1960s and was periodically closed. It was replaced in the late 1960s when the state highway department authorized a new $170,000 bridge at that location. (Photograph by Ches Johnson.)

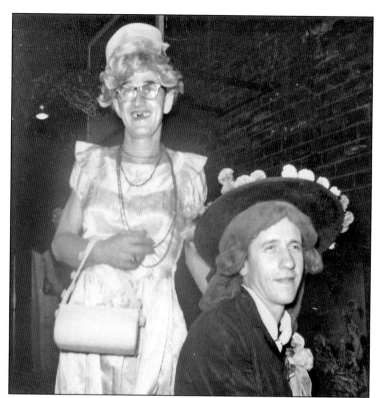

WOMANLESS WEDDING. These beautifully clad ladies are actually men. They are dressed to the nines for a womanless wedding at Alvaton High School around 1960. Womanless weddings were common fund-raisers around the mid-20th century. The female on the left, dressed in a lovely satin number and pillbox hat, stands beside the dowdy Henry Goldsmith Sledge, who played the piano for this campy affair. (Courtesy of William Sledge.)

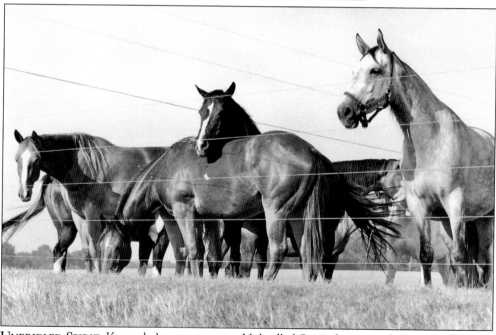

UNBRIDLED SPIRIT. Kentucky's newest motto, Unbridled Spirit, has proved quite popular with tourists and with home folk. Certainly horses and Kentucky are synonymous. Here a tangle of the noble beasts stands close to their boundary fence and watches the cars go by. (Photograph by Joerg Seitz.)

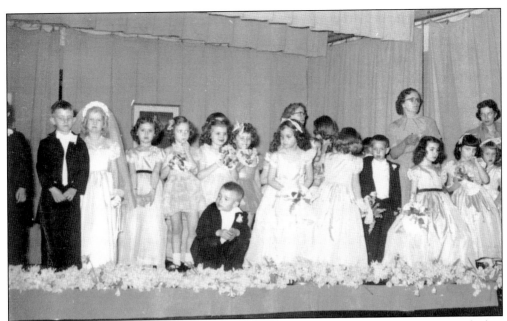

MUNCHKIN WEDDING. Tom Thumb weddings have been popular fund-raising events since the late 19th century. They generally were conducted as fund-raisers, because the appearance of children guaranteed an admiring audience of parents and other family. This diminutive event took place at Alvaton High School on March 16, 1954. A majority of the wedding party is located on the school stage. (Courtesy of William Sledge.)

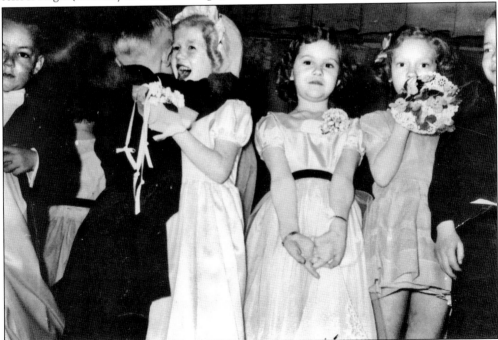

THE WEDDING COUPLE. The bride, Jennifer Lee Sledge, and the groom, James Robert Buchanon, are featured as the groom proffers a hug rather than the customary kiss upon marriage. As the bride beams, the two girls to the right seem transfixed by the camera. (Courtesy of William Sledge.)

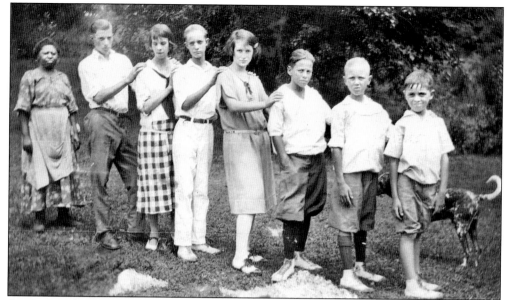

AT CAMP. These children are part of several families that spent a sunny afternoon at a camp near the old Martinsville ford on the Barren River. This 1920 photograph may have been taken after a picnic, since everyone is dressed up. The participants are, from left to right, Nora West, Joseph Gadd, Mary Gadd, Hugh Moore Manar, Elizabeth Phillips, James Phillips, Fred Manar Jr., and Jack Manar, and the dog is Tag Phillips.

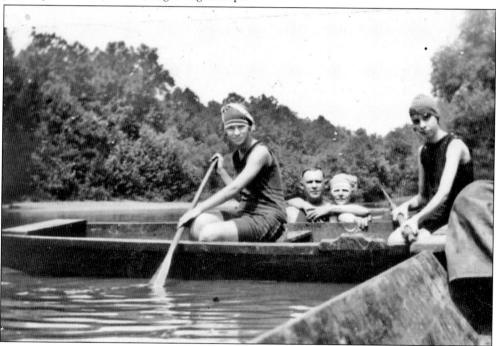

MAN THE OARS. These ladies are out in a small skiff on the Barren River at the Martinsville ford. The owner of this photograph, with tongue in cheek, wrote on the back "the bathing beauties of Martinsville ford a la '24; such brevity, tsk tsk." The shallow ford here allowed for crossing; it is no longer used today, but the road still goes down to the river.

COOKING IT UP. These women are part of the Manar clan out at their camp on the Barren River at the Martinsville ford. Taken in approximately 1920, the two women are busy fixing a meal at a gas stove outside. The man behind them is not beating them; he is shooing away flies. The Barren River, which winds from Monroe County to Warren County, is the largest tributary of the Green River.

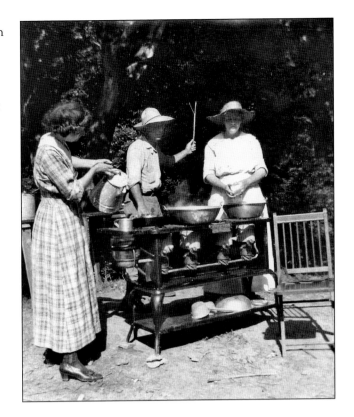

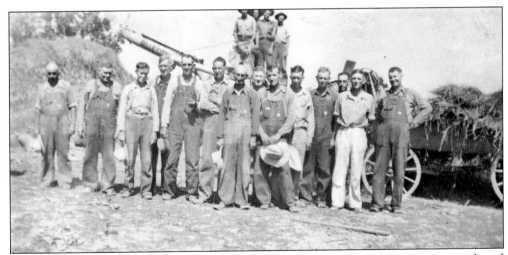

THE THRESHING CREW. Harvest time always requires cooperation. Here men are gathered to help thresh wheat in the Bays Fork area. In the top row, only Henry G. Sledge is identified (third from right). At the bottom from left to right are Gilbert Howell, Claude Corbitt, Jerome M. Sledge, Lee Buchanon, James H. Foster, Cliff Smith, Wood Pearson, Roy Denkins, Charles A. Sledge, Warner Simpson, William I. Sledge, Opal Conner, Alfred Dunning, and Roy Lester Sledge. (Courtesy of William Sledge.)

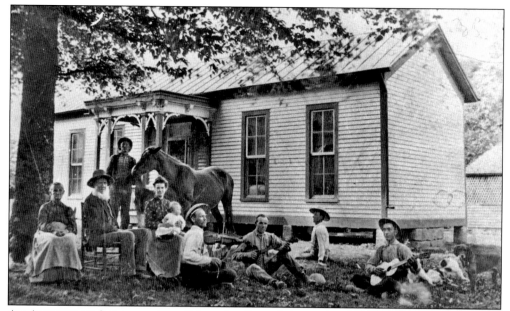

AN AFTERNOON SERENADE. The Osborn family settled near the old Iron Bridge in southeastern Warren County. Not all the members in this photograph are fully identified; the people are, from left to right, Nancy Manley Osborn, Reuben Bolivar Osborn, Douglas, Gertrude with Baby Raymond, Ewing, Reuben Bolivar Osborn Jr., William, and Herschel Moore. Although part of the Osborn family moved to Missouri in the late 19th century, they eventually returned to Warren County.

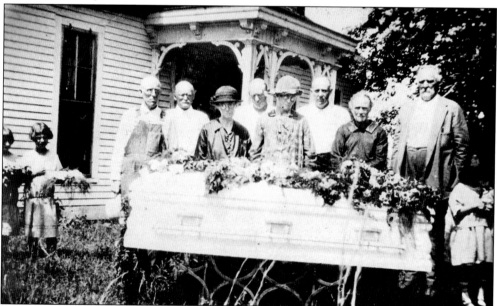

MOURNING AN OSBORN RELATIVE. A deceased Osborn family member is mourned outside the family home. Of course, it was not unusual in the 1920s—when it appears that this photograph was taken—for a funeral to be held at home, and many a family member has stayed up all night to watch the casket. These photographs are not uncommon. Sometimes a portrait of the deceased is included in the photograph.

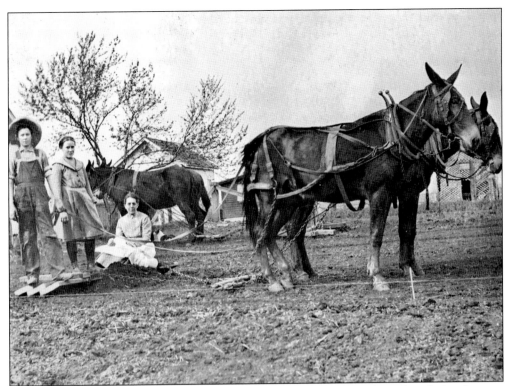

CULTIVATING THE GARDEN. This family is out in the garden getting the soil ready for planting. The two children are standing on a board that, when pulled by the mules, will help clear the ground and level it out after plowing. Mother is waiting to begin planting the seeds.

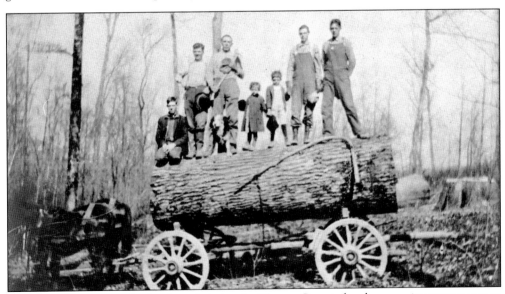

LOGGING. Harvesting the hardwood timber in Warren County has been an important way to supplement the farmer's income and to clear land. Sometimes timber rights were sold to professional lumbermen, and other times the owner and his family felled the trees themselves. That is obviously the case with this behemoth log. It is believed that this family was from the Claypool area.

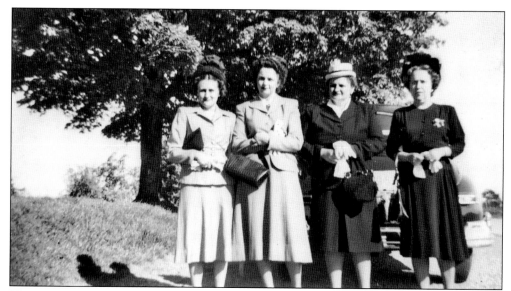

WOMEN ON MISSION. These ladies have just finished with a Woman Missionary Union meeting at Bethany Baptist Church near Alvaton in the 1940s. They look particularly fervid and ready to zealously apply their missionary knowledge. The ladies are, from left to right, Regina Kirby Hines, Francis Sears Bates, Ivy Pearce, and Lelia Mae Sears Comfort. (Courtesy of Elizabeth Hammersley.)

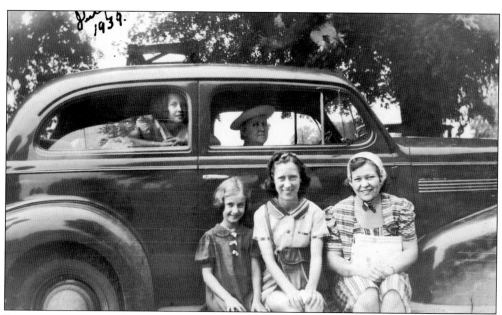

READY FOR A DAY IN TOWN. These Alvaton ladies are getting ready to go to town on July 4, 1939. The women in the auto are Wilodene Sears (left) and Maude Sears. On the running board from left to right are Elizabeth Comfort, Ruby Robertson, and Opal Sears. Perhaps the ladies are going to town to celebrate Independence Day. (Courtesy of Elizabeth Hammersley.)

OL' PETE. Dorothy Grider (1915–) is shown here standing next to her painting of "Ol' Pete," a former slave who worked for Col. J. W. Krueger on the Scottsville Pike. Grider executed the painting in 1937 when she was only 19 years old. The painting won a contest, with the prize being a scholarship to the Phoenix Art Institute in New York City. Grider went on to illustrate books for children, paper dolls, games, greeting cards, and playing cards.

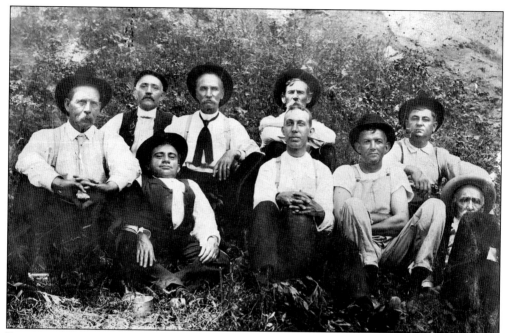

BASKING IN THE SUN. These men are enjoying a day of relaxation out on the Barren River. The owner of the photograph captioned it: "On the bonnie banks of Barren, Labor Day, Sept. 7, 1908." The small man second from the left is attorney T. W. Thomas.

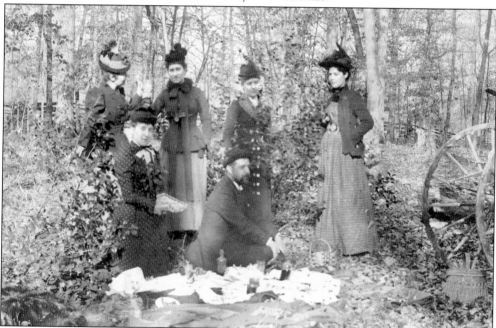

THE LONE RANGER. Robert Covington enjoys a luncheon picnic with his female guests Mary Underwood Poyntz (kneeling), Myrtle Smallhouse Garth (standing second from left), and Elvira Hines Gaines (standing third from left). The other ladies are not identified. The photograph was undoubtedly taken on the old Covington farm on Scottsville Road. In the background notice the old Virginia rail fence.

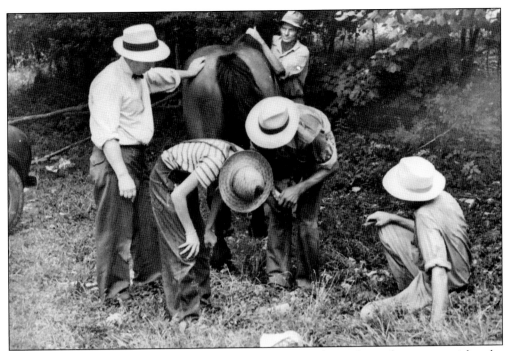

CHECK OUT THOSE SHOES. A horse with a bad shoe is no joke, and most horses are quick to let their riders know if something is wrong of if a stone has wedged itself in their hoofs. These men are diagnosing a problem. Few men had the material or resources to shoe their own horses, so they were generally taken to the local blacksmith for a sure fit.

HORSEPOWER OF A DIFFERENT KIND. Neal Comfort and Tommy Smith are trying to diagnose the problem with their automobile at the E. H. Comfort home in the Alvaton area in 1939. (Courtesy of Elizabeth Hammersley.)

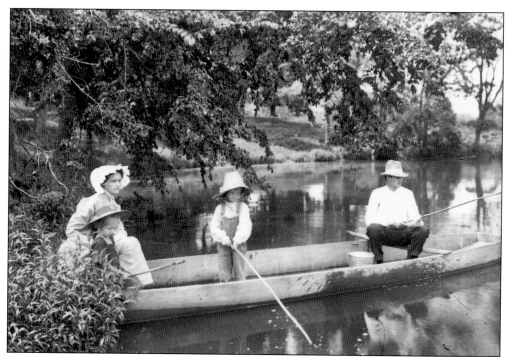

ANTICIPATION. The Bohon family is out for a day of fishing and relaxation on Drakes Creek. The family members are, left to right, Julia, Sarah, Will and George. (Photograph by George C. Willis.)

A FAIR CHICK AMONGST THE HENS. Pictured here is Hattie Emma Donoho with her flock of chickens near the Cassaday community.

WAITING FOR SCHOOL. Laurita Willoughby (left) and her sister, Chloenita Willoughby, sit in front of the old Bays Fork School in the late 1940s, shortly before the school was closed. Students from this school transferred to the Alvaton School. The classroom was on the right side; grades one through eight met in that room with one teacher. The room across the hall had a platform built at one end and was used for school activities. It is a private home today. (Courtesy of Laurita Sledge.)

LEARN 'EM SOMETHING. Agricultural instructors from WKU (at the right in coats and ties) have just taught a rural training session at the Bays Fork School. The class, which was for the entire community, was held in the classroom portion of the building. Notice the large stove at the right margin. (Courtesy of Laurita Sledge.)

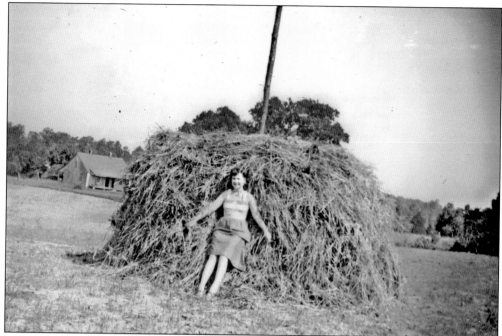

HAY GIRL. When visiting family on the Willoughby farm off Sledge Road, Aline Railey of Louisville was attracted to the haystacks farmers were constructing. She poses in front of a half-finished stack. The hay was layered in a particular fashion on top to keep the rain out of the center of the stack; each haystack could be up to 14 feet in height. (Courtesy of Laurita Sledge.)

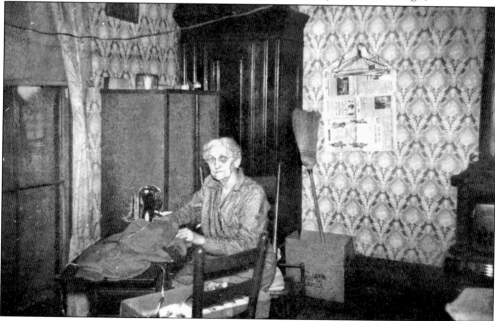

NIMBLE WITH THE NEEDLE. Lena Comfort is shown inside her Alvaton home at a familiar spot, behind the sewing machine. Lena was widely known as an outstanding seamstress. Besides selling products such as eggs and butter, sewing at home was one of the few ways that a woman could make some expendable income. (Courtesy of Elizabeth Hammersley.)

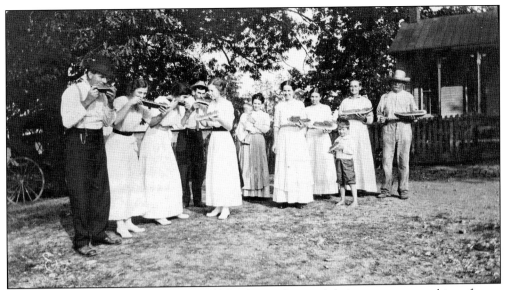

Tasting the Forbidden Fruit. Howell family members and their guests are partaking of some watermelon around 1910 at the Howell farm off Cemetery Road. The Howell farm was located directly on Drakes Creek; the family raised tobacco, corn, and alfalfa. John Ewing Howell and his wife, Patsy Ann Howell, are on the far right. (Courtesy of Pat Motley.)

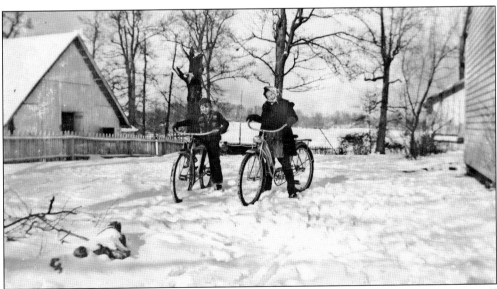

Hot Wheels. On a Christmas Day in the early 1940s, Glenda B. (left) and Patricia Howell are trying out their new bicycles in the snow. They are on the Homer Howell farm in Motley, Kentucky. The building in the background was referred to as the woodshed; the central aisle was used for storing dry wood. A space for the family automobile was located on the left side of the building; a shop occupied the right side. (Courtesy of Pat Motley.)

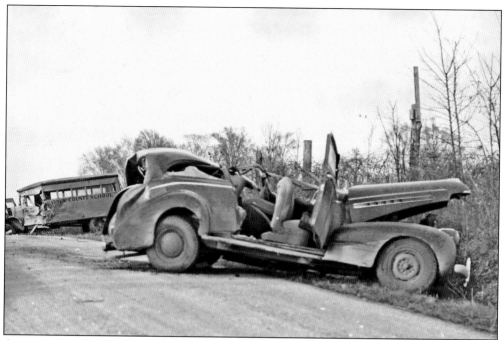

ALVATON BUS CRASH. This photograph documents a harrowing event in the Alvaton community. A Warren County school bus was delivering children home when it hit an automobile on Highway 71 (today's Highway 231). The driver of the automobile was killed in the accident.

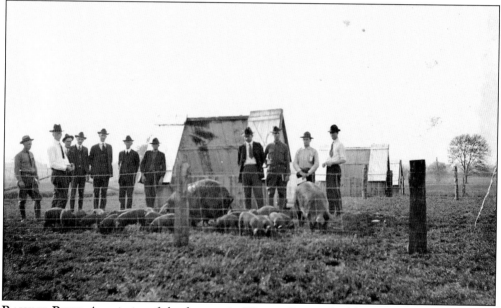

RAISING PORK. A majority of the farmers in Warren County had hogs to sell or raised them for family consumption. As winter encroached, farmers butchered the animals during a period known as "hog killing time." Families ate the organ meat first, as much of the remainder of the animal could be saved by curing the meat. Ribs were commonly consumed quickly; scraps were ground and made into sausage. Fat was rendered into lard and used throughout the year. In this photograph, pigs are being shown at a demonstration event.

Five

SOUTHWEST WARREN COUNTY

TOP FORM. Lewis Richard "Dick" Duncan (1902–1993) was a champion horse trainer. At one time, he operated a farm with training facilities in the Woodburn area. Dick showed several national champions, including a favorite of his, Jacqueline McDonald, in 1939 at Madison Square Gardens. He traveled extensively in his work and even judged horse shows as far away as South Africa.

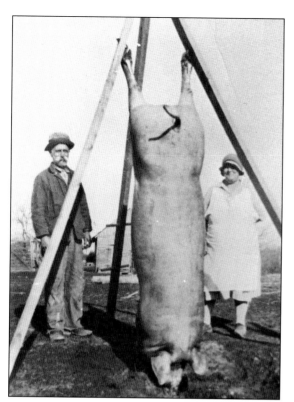

A South Central Kentucky Tradition. Butchering hogs was a common winter task on most farms in the area. Here the Pedigos have a hog hanging using the tripod and hook method in 1916. Many people just tied the hog's hind legs to a "gatlin" pole and hung it up in the barnyard. This work was done in cold weather, which prevented the meat from ruining. (Courtesy of Folklife Archives, WKU.)

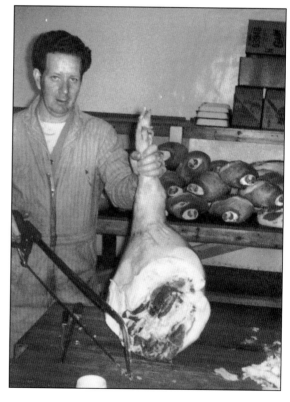

Hamming it up for the Camera. David Logan is shown here with a "rough ham." After trimming the ham, Logan rubbed saltpeter on the cut bones to preserve them. Afterward he rubbed the hams with sugar and packed them in salt for approximately three weeks. The hams were then ready to be hung in the smokehouse, where they were smoked for at least four nights. A properly cured country ham has a perfect balance of sweetness and saltiness, and is it good! (Courtesy of Folklife Archives, WKU.)

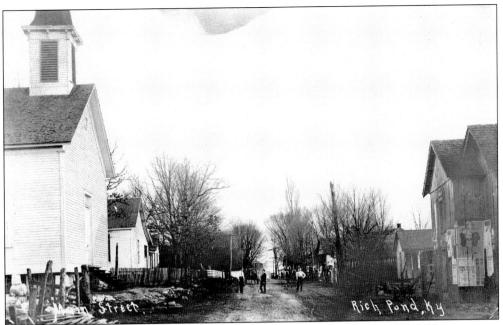

EARLY RICH POND. This is a rare view of Main Street in Rich Pond around 1910. No one seems to know the origination of the town's name. A number of natural ponds are located in the area. No families named Rich appear in extant census records. Rich Pond appears on early maps and is mentioned as early as 1811 in county land records. The large church in the foreground is the Rich Pond Church of Christ. Notice all the placards pasted to the building on the right margin.

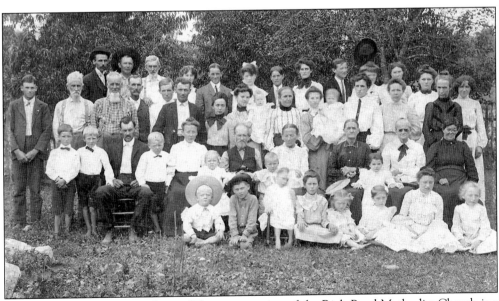

I DARE YOU TO MAKE ME SMILE. The congregation of the Rich Pond Methodist Church is a rather somber assemblage in this c. 1900 photograph. Included in the Woodburn Circuit of the Bowling Green District, this church existed from around 1880 to 1934. Due to declining revenues, the Woodburn and Rich Pond congregations consolidated in 1934; the property and furnishings were sold at an auction on June 28, 1934. (Courtesy of Stephen King.)

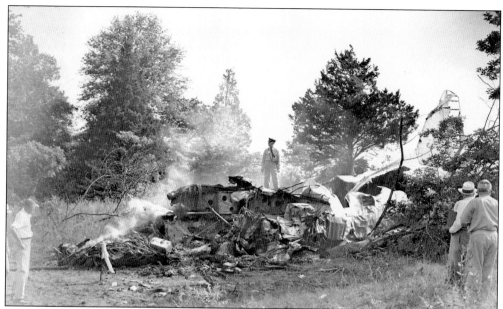

TRAGIC CRASH. This photograph was taken on July 30, 1943, the day after an Eastern Airline flight crashed right outside Warren County at Trammel. Twenty people, including several servicemen and all the crew, lost their lives in this accident, which happened during a bad summer storm. By breaking windows and escaping, two men actually survived the horrendous fire that ensued. The flight was en route from Louisville to Nashville.

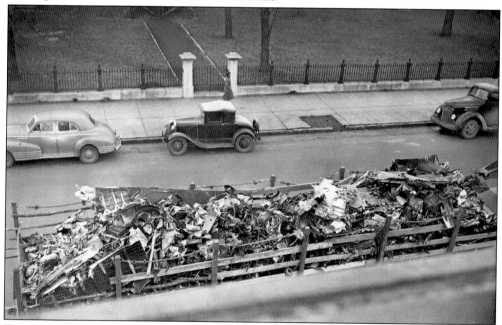

THE REMAINS. This photograph shows what is believed to be the collected debris from the crash, which was hauled to Bowling Green on a long flatbed trailer. The trailer is parked in front of city hall. The photograph also documents the northern entrance to the old courthouse; in this photograph, the entrance includes a temporary platform constructed for some political speech or event. This entrance was changed to a window during a 1950s renovation of the courthouse.

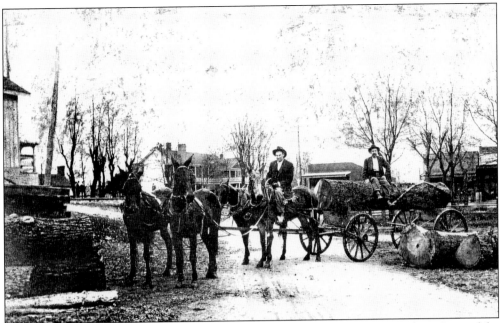

WE CALL IT WOODBURN FOR A REASON. These men have parked their logs right in front of the Woodburn depot in 1913. A small portion of the depot can be seen at the left margin. Part of the downtown business district and the depot park can be seen on the right. The shading in the background was done by a child who thought this photograph should be colorized. (Photograph by Joseph Eccleston Flanigan.)

WORLD WAR I VETERAN. Thomas O. H. Gaines, from Rockfield, is shown with his pistol drawn and atop his trusty steed while in training at Camp Taylor in Louisville. He served in the army during World War I. He died in 1926 from tuberculosis, which he contracted while working at the DuPont Silk Mills in Old Hickory, Tennessee. He is buried at the Pleasant Hill cemetery.

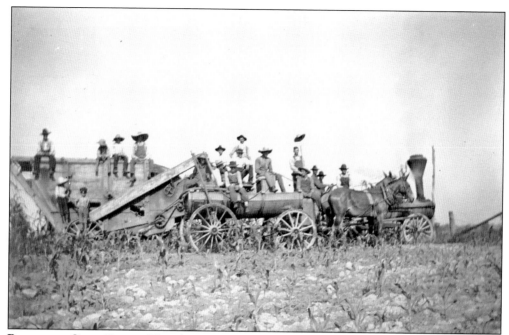

BEHEMOTH CORN EATER. This photograph features a steam-powered corn thresher. The mules pull a wagon that will haul the corn to storage facilities or to the mill. Even with mechanized harvesters, it still took a number of folks, as seen here, to complete the gathering process. The donor dated this photograph to around 1890.

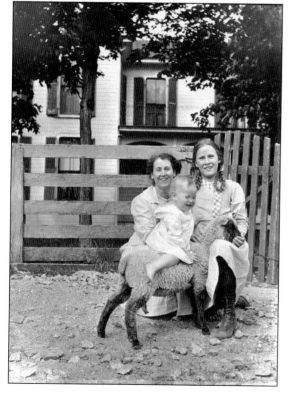

ITS FLEECE WAS WHITE AS SNOW. This Woodburn area family, posed in front of their home, is enjoying two young ones. The young boy, simply named J. D., is astride one of the family's new lambs. Children on farms often developed affectionate bonds with the animals.

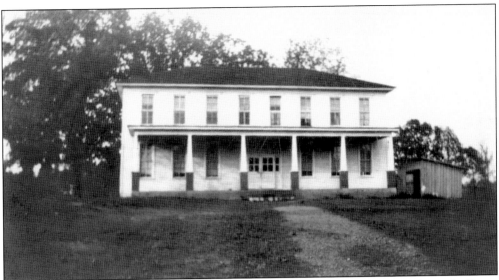

BOYCE SCHOOL. In 1915, several schools in the southern part of the county merged into the Boyce School, which offered coursework for the first eight years; a high-school program was added in 1918. The region's progressive citizens, who favored school consolidation, actually erected this building. One interesting early squabble at Boyce dealt with the introduction of basketball; some families forbade their children from participating in a game that required players to wear "indecent garb."

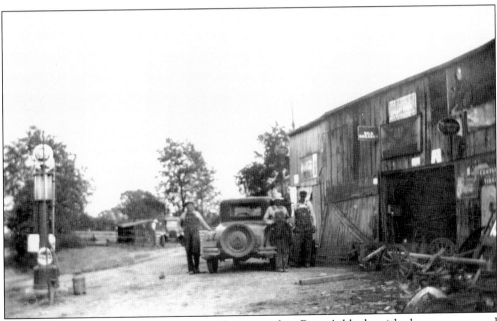

MULTI-FUNCTION BUILDING. This building served as Boyce's blacksmith shop, garage, and mill. The gasoline pump is located almost directly on the road, which seems rather dangerous. Blacksmiths shod work animals, repaired agricultural equipment, and made custom replacement parts for all types of contraptions. This photograph, taken in 1935, indicates that this local business must have presented a colorful appearance on this barren road with its many advertising signs and the detritus cluttering the building's facade.

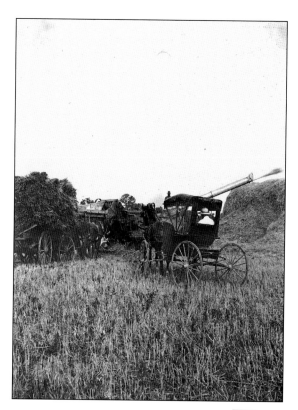

MOUNTAINS OF STRAW. After the threshing machine had done its work and the grain was collected, mountains of silage had to be dealt with. Most farmers collected this refuse material and used it for bedding for farm animals and to stuff their own tick mattresses.

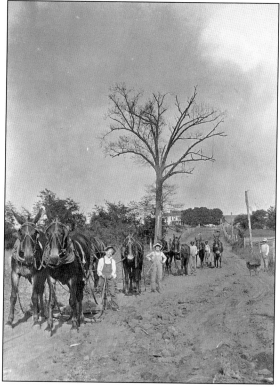

WORKING THE ROADS. Helping maintain the roads was a constant chore for men. Here farm boys in the Woodburn area are helping grade the roads near their farms. In older times, the organized militia helped maintain roads. After the Civil War, this often fell to property owners who lived along the rural roads. Toll roads, which were quite common in the late-19th-century Kentucky, were a means of helping disseminate repair costs to those who used the roads most.

OUT FOR A RIDE. Silas Stone holds on for dear life as Albert Cox takes him for a ride on his Indian motorcycle around 1918. The young men were from the Rich Pond area. Silas Stone died in 1922 from typhoid fever. He and his brother, Paul, once ran a pool hall in downtown Bowling Green. He made extra money by setting up a portable outside skating rink at fairs and other events. Cox had a military career and was later instrumental in WKU's early astronomy program. (Courtesy of Sue Lynn McDaniel.)

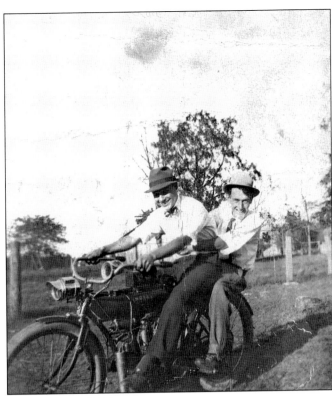

CRUISING. Mary and Luther Smith are seen on the Smith family farm near Woodburn, Kentucky. The family later bought the old Covington farm south of Bowling Green and operated the Elm Grove Dairy there for decades.

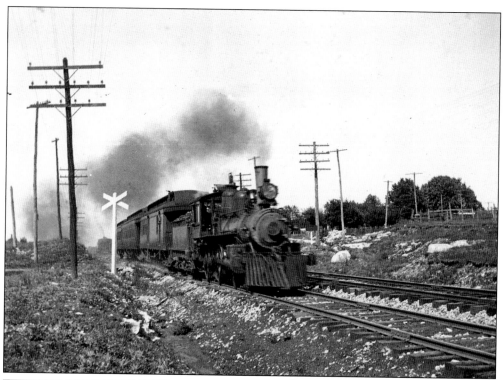

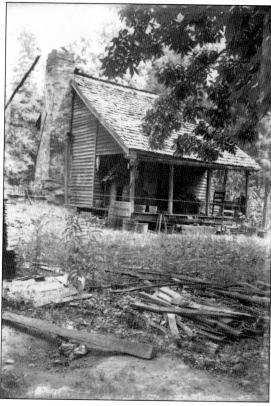

CHOO CHOO! This photograph of a Louisville and Nashville (L&N) train was taken just outside of Bowling Green, near Memphis Junction. The train includes a steam engine, a coal car, and three passenger cars. Memphis Junction was at one time simply where the L&N's Memphis branch headed west, while the main branch went straight south. When the new depot was built in 1925, much of the line's local freight operations were moved from the congested downtown area to Memphis Junction.

RUSTIC BEAUTY. This vernacular frame home was located in the woods near the old Whitestone Quarry. It was owned by an African American gentleman who may have been a laborer at the quarry at one time. Notice the water barrel at the corner of the porch and the large limestone step in front.

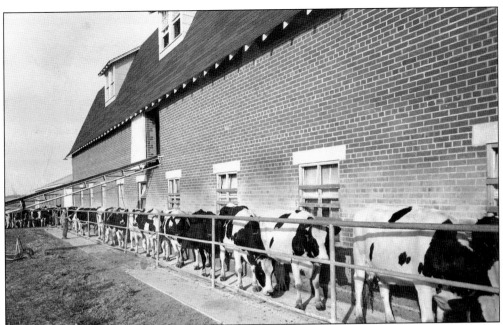

SINGLE FILE, PLEASE. Forest "Pappy" Borders (1893–1971), pictured below, was one of Warren County's most successful dairymen. He operated a large dairy off the Three Springs Road and a milk processing plant on Tenth Street in Bowling Green. His business was almost self sufficient; he grew his own alfalfa, processed the milk from his Holstein cows, produced dairy products, and marketed them. He loved the land and farmed scientifically in order to produce the largest yield while conserving the fields. Borders Pure Milk Company products included milk, buttermilk, sour cream, cottage cheese, butter, and ice cream. The company's pledge was to provide "the finest dairy products we can obtain and process through the most rigid Quality Controlled Program." For many years in the 1950s and 1960s, Warren County consistently ranked in the top five dairy producing counties in Kentucky.

HILL OF ROCK. These large pieces of stone have been rejected at the Whitestone Quarry. Many of these pieces were later broken up and sold by a Nashville company for use as roadbed material; some were pulverized and used for agricultural purposes.

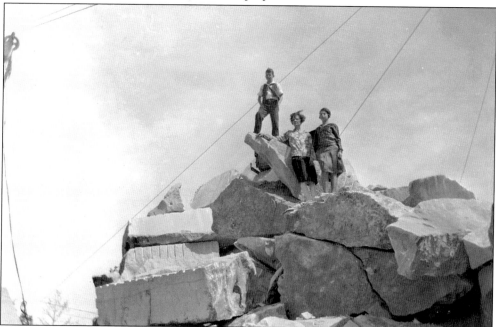

KING OF THE HILL. These visitors are standing on some of the rejected stone from the Whitestone Quarry. One of the stones in the bottom left side of the photograph shows an array of one-foot grooves. This is where the workers drilled into the stone to aid in making a straight cut from the larger slab.

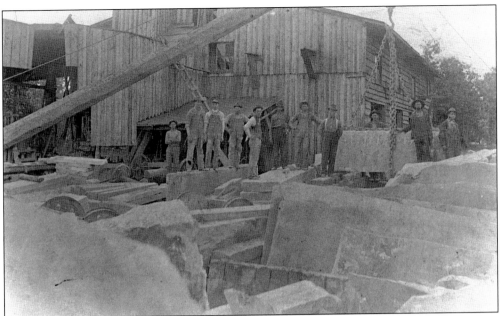

CUTTING THE ROCK. Prior to the introduction of the Southern Cut Stone Company in Bowling Green, all the stone was cut at a facility near the Whitestone Quarry. These men are loading pieces of stone to be taken inside and cut into specified widths and lengths for the building industry. Bowling Green limestone was highly desired for its strength, color, and the ease with which it was carved.

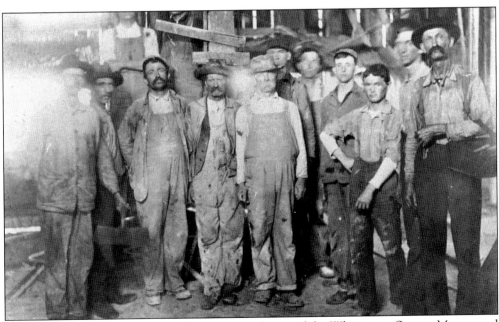

HARD WORKERS. These men and boys were employees of the Whitestone Quarry. Men owned their own stone-cutting tools. Sometimes these were sold or used as collateral when a man needed a loan. The work force at the quarry included a number of immigrants, including Italian, Irish, and English stonecutters.

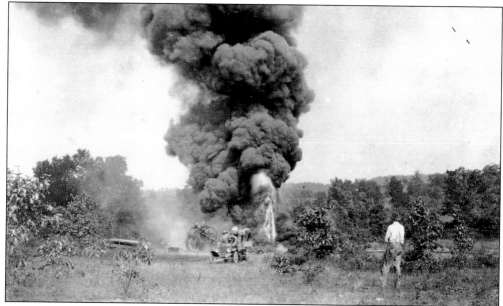

LET HER BLOW! Warren County experienced a short-lived oil boom from 1917 to 1921. Wildcatters unmercifully pierced Warren County's soil for black gold during the period. This particular photograph was taken at the Kelley oil field near Rockfield. Wildcatting took place throughout the county. Oil and gas exploration continues in Warren County to this day.

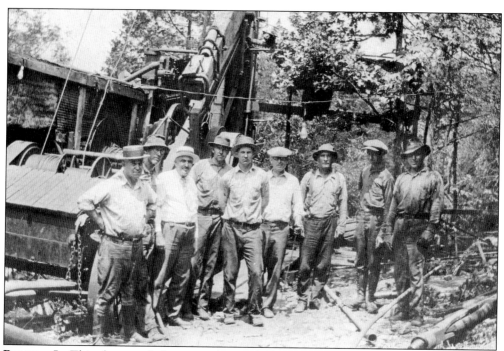

RIGGING IT. This photograph shows an oil crew drilling in Warren County in August 1927. The men are, from left to right, Charles Onsel, Mr. Baldwin, George McGinley, Mr. Garrison, Carlos Tabor, Mr. Hannihan, Fred Humble, Mr. Manning, and Paul McGinley.

A Gaping Hole. This mill, located atop Lost River Cave was constructed in 1874 by John W. Row. This was actually the second mill at the cave, but the original one was located inside the cave. Row's mill was supplied with water pumped up to the surface through a pipe. This pipe ran through a drilled hole in the roof of the cave and ended at the river. When the river was low, the water was pumped to a steam engine that powered the mill. This mill burned to the ground in 1915. The mill also boasted a distilling operation for many years.

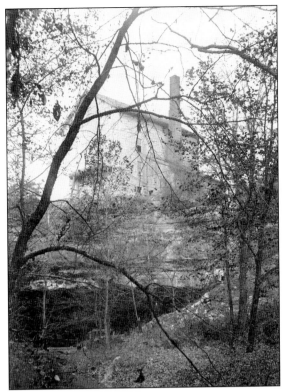

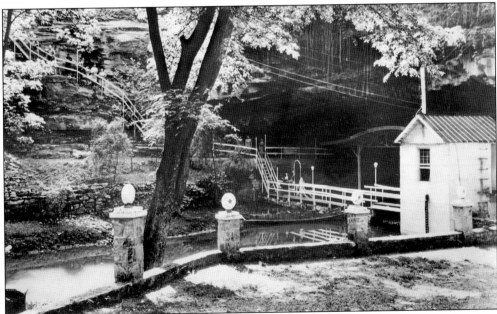

A Thriving Enterprise Down Under. This photograph shows the electric generating plant (small white building) and some of the lights in the Lost River Cave Valley. Also visible to the left of the white building is the old dance pavilion located in the mouth of the cave. Tourists are descending the winding stairway from the Nashville Road entrance down to the cave. The Lost River Cave and Valley is once again a thriving tourist destination for the community.

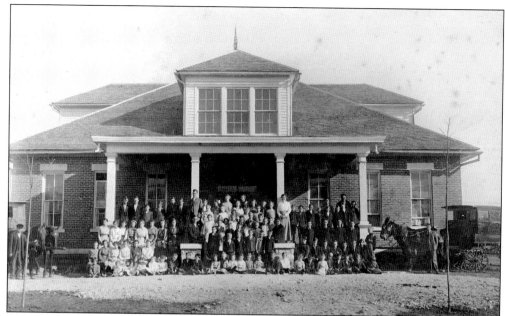

RICH POND SCHOOL. This photograph was taken soon after the Rich Pond School was finished in 1915. The commodious masonry and limestone school boasted numerous windows; dormers on each side pierced the roof and allowed for even more natural light. The school cost $5,885 to build; of that amount, local patrons provided $1,750. On the first day of classes in 1915, three teachers welcomed 112 students. Many Rich Pond students came to school in wagons, one of which can be seen in the right margin of this photograph. (Courtesy of Stephen King.)

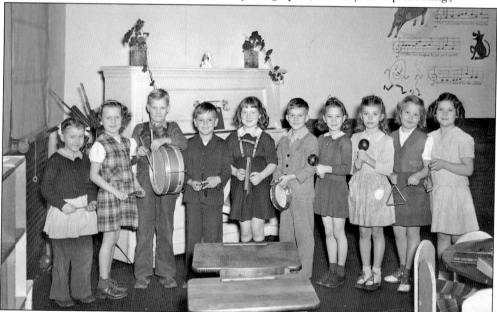

RHYTHM SECTION. These children are learning to deftly handle their musical instruments, ranging from the triangle to the tambourine. They are taking lessons from the music teacher at Rich Pond Elementary School in 1947. A number of this school's photographs were left to the Kentucky Library by longtime principal Anna Lee Briggs.

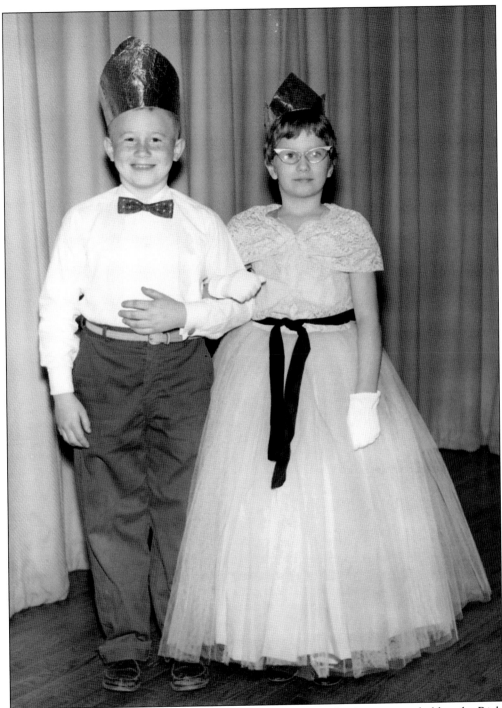

LILLIPUTIAN ROYALTY. This proud duo has been named royalty for an event held at the Rich Pond School. Although the photograph is not dated, others with it suggest this is from the late 1950s.

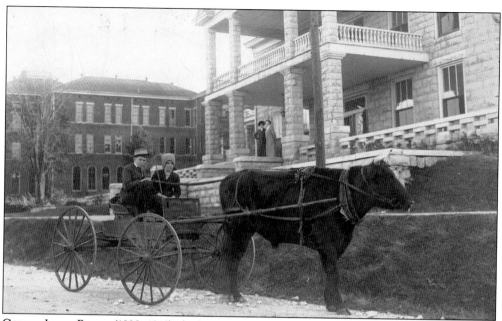

CORNY. Lester Bryant (1898–1913), the boy pictured in the buggy, was the 1912 Kentucky champion corn grower. He grew 148 bushels of corn on one acre on his father's farm near Rockfield. The *Courier-Journal* paid for his trip to Washington, D.C., to attend the national parade of winners. While preparing for bed in a Washington hotel on January 19, 1913, he blew out the gas jet in his room's light fixture and asphyxiated. The stone building you see is Cabell Hall, and the brick building in the background is the old Potter College's Recitation Hall.

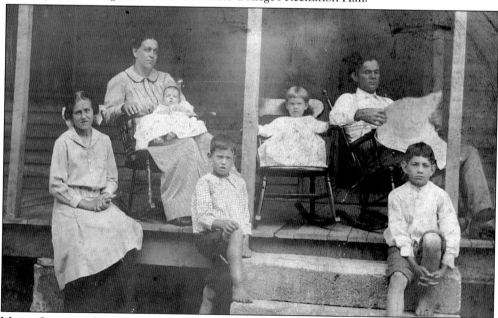

MINUS LESTER. This photograph of the Bryant family was taken several years after Lester's death in Washington, D.C. Photographed on the porch of their Rockfield home are, from left to right, (first row) Clara Grace, Carlton, and B. H.; (second row) mother Ruth Ann holding baby Lucy, Ida Ruth, and father William Allen. (Courtesy of Alicia [Howell] White.)

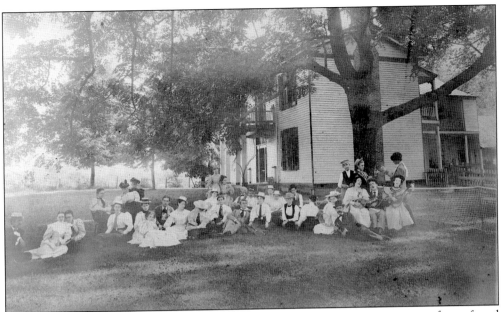

SEMINARY EDUCATION. Female educational institutions in the Victorian era were often referred to as seminaries. Many of these schools were located in rural settings. Outside Woodburn, the Cedar Bluff College was one of Warren County's most renowned educational institutions. William F. Whitesides founded the institution in 1862, and it survived until a fire destroyed the facilities in 1892. Young ladies took classes ranging from Latin and arithmetic to wax flower making and elocution. Not all the students appreciated Cedar Bluff's sylvan setting; one young lady wrote: "I think this is certainly one of the most secluded spots on earth." Pictured above are some of the young ladies attending to important matters other than their studies. Young gentlemen have been allowed to invade campus for a fun day of sport on the tennis court adjacent to the school's main structure. Below the girls have gathered on the back porch, which looked out onto a lovely garden area.

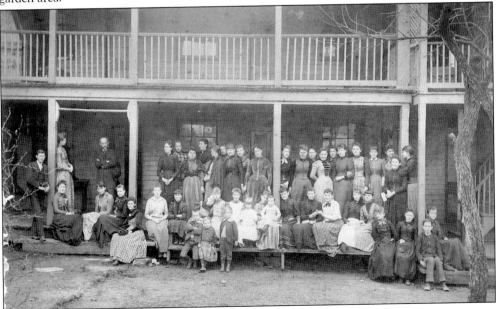

A BOY AND HIS PONY. Most children dream of having their own pony; this boy is sure proud of his young steed. (Photograph by George C. Willis.)

CHILDREN OF THE CORN. Sometimes it doesn't take much to capture the imagination of children. Pictured from left to right, Sarah Willis Bohon, Will P. Bohon, Marion Kellog, and Willis Kellog are sitting at the edge of the cornfield, contemplating some kind of mischief no doubt. (Photograph by George C. Willis.)

CHILDREN AND THEIR NURSE. Sarah and Will Bohon pose with their nurse out on the lawn. They've stopped their play to have a snack. (Photograph by George C. Willis.)

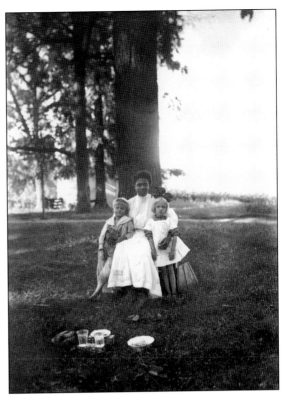

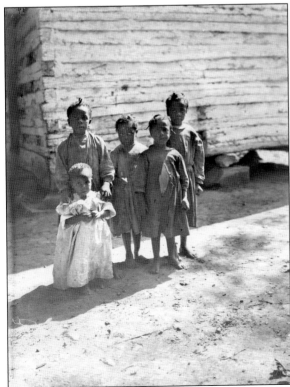

POSING FOR THE CAMERA. These precious children are unidentified, but the photographer locates them in the county's southwestern section. Perhaps they were children of a sharecropper, and the old log house in the background was their home. (Photograph by George C. Willis.)

ROCKFIELD SCHOOL. The old Rockfield School was designed by James Maurice Ingram and built in 1930. The masonry structure was named South Warren in 1942. The high-school portion was discontinued when Warren Central High School was completed. The school remained open until the new Rockfield School was finished in the mid-1970s. Several antique stores have used the building, which retains a prominent spot on Highway 68-80.

ROCKFIELD SCHOOL STUDENTS. This is the Rockfield High School senior class of 1938. The students are, from left to right, Lee Royce Miller, Mae Ellis, Anna Mae Shanks, Zula Paul, Alleye Heard, Marguerite Smith, Bessie Mae Chaffin, and Russell Christian. Notice that several of the students are proudly sporting their letter sweaters. Boys could play basketball or softball, and the girls had a softball team.

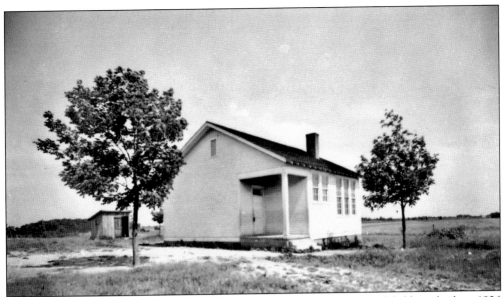

ROSENWALD SCHOOL. This school for African American children in Rockfield was built in 1926 with money from the Julius Rosenwald Fund. Rosenwald, a philanthropist who amassed great wealth from his association with Sears, Roebuck, and Company, helped build African American schools throughout the South, including three in Warren County. The Rockfield school had one large classroom, a smaller community room, two small cloakrooms, and a corner porch. It has been adapted into a private residence. The other Warren County schools were in Bristow and Delafield.

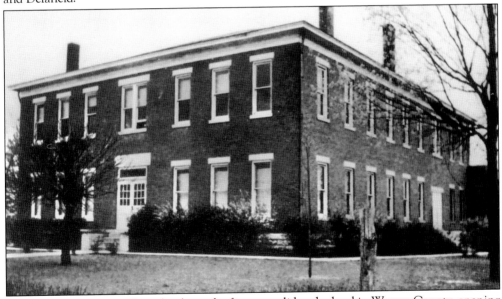

WOODBURN SCHOOL. This school was the first consolidated school in Warren County, opening its doors in 1915 with O. C. Davis as its principal. The building had four classrooms on the first floor and an auditorium on the second floor. Over the years, a number of changes were made to the building, including the addition of office space, a new auditorium and cafeteria in the basement, new classrooms, a laboratory, and a library. The high school was moved in 1941; the elementary school continued here until the early 1950s.

DISCOVER THOUSANDS OF LOCAL HISTORY BOOKS FEATURING MILLIONS OF VINTAGE IMAGES

Arcadia Publishing, the leading local history publisher in the United States, is committed to making history accessible and meaningful through publishing books that celebrate and preserve the heritage of America's people and places.

Find more books like this at
www.arcadiapublishing.com

Search for your hometown history, your old stomping grounds, and even your favorite sports team.